Journey through

BERLIN

Photos by

Jürgen Henkelmann

Text by

Volker Oesterreich

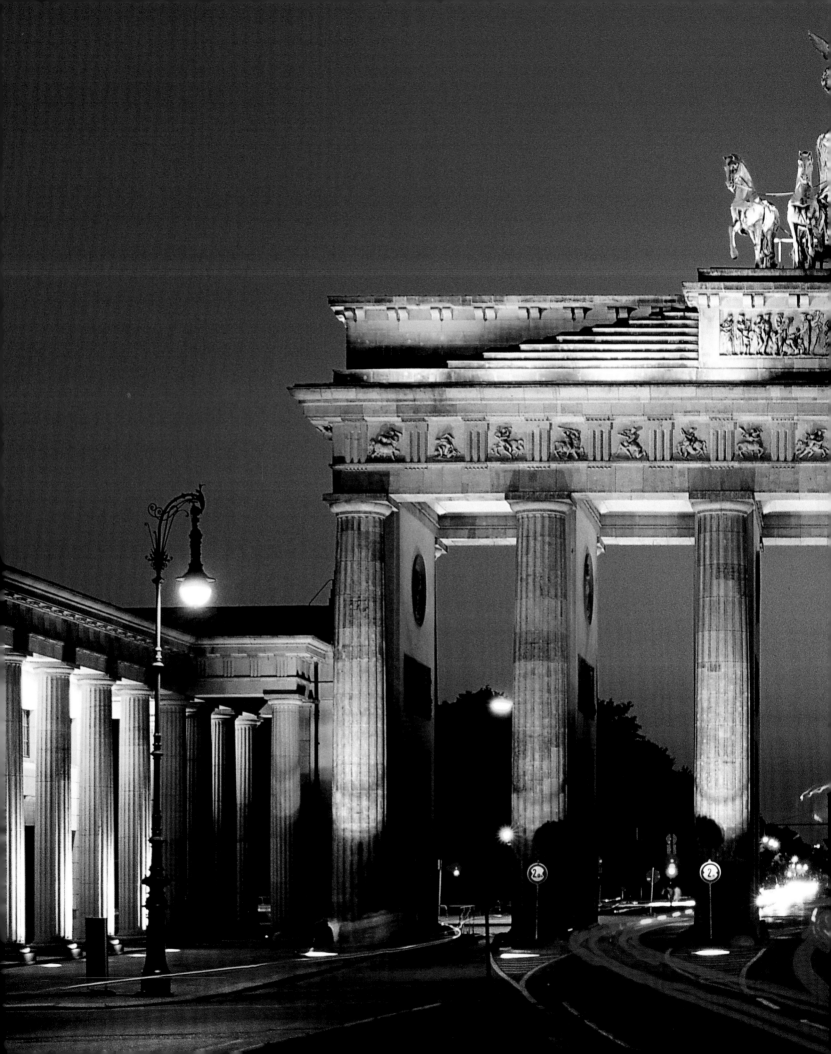

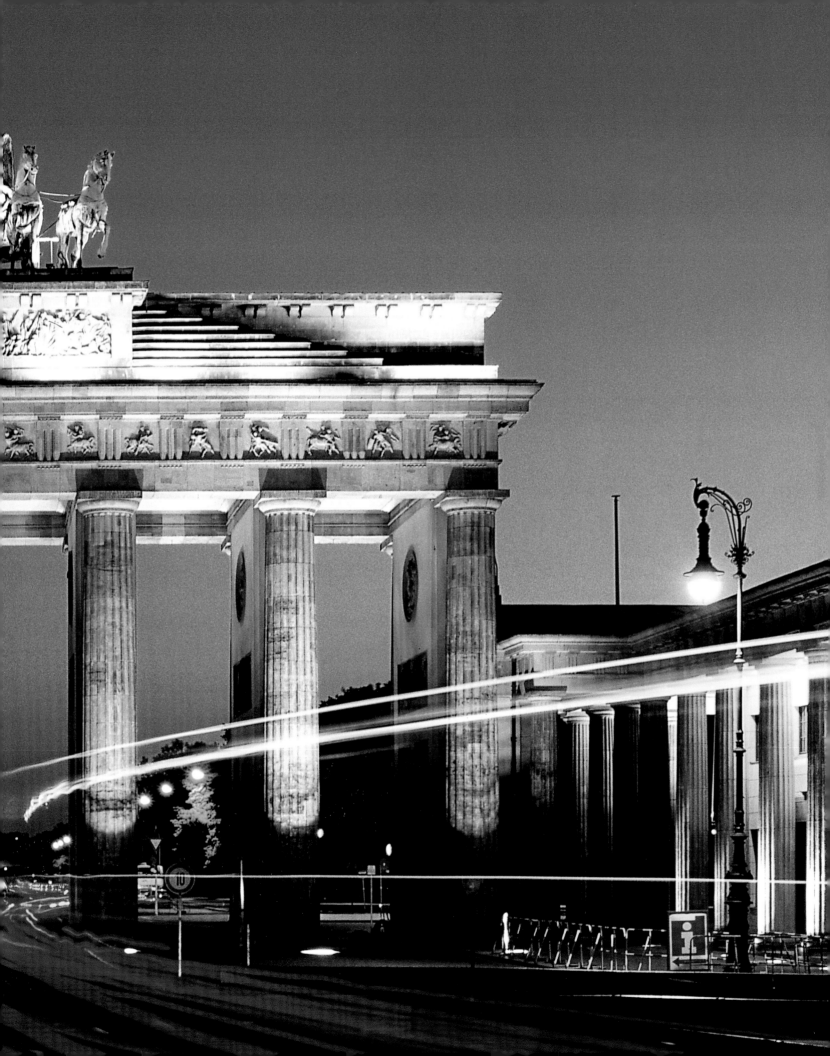

CONTENTS

8

that for decades this was where NATO and the Warsaw Pact stared each other down in stony silence.

Below:
Shops selling postcards and souvenirs have

usurped the barbed wire at Checkpoint Charlie.

Page 10/11:
The show is just about to start at the Musical Theatre (right) on

Marlene-Dietrich-Platz, one of the new edifices on Potsdamer Platz, the

new district now throbbing with life in the heart of Berlin.

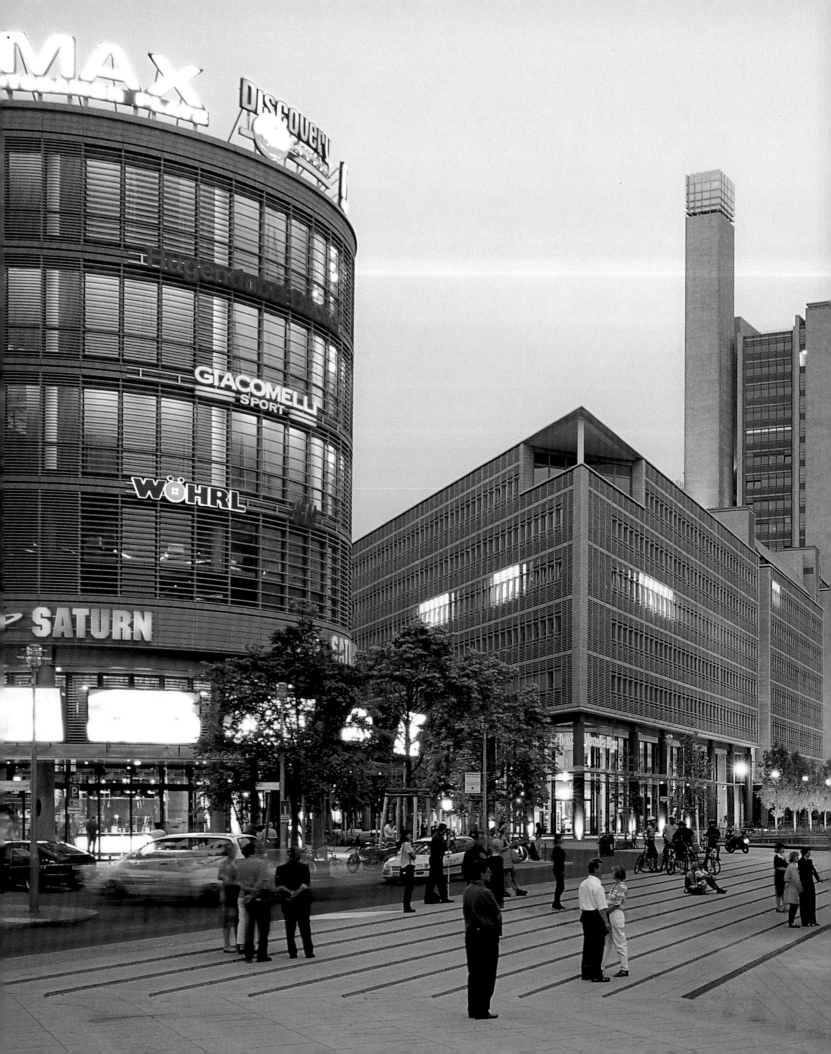

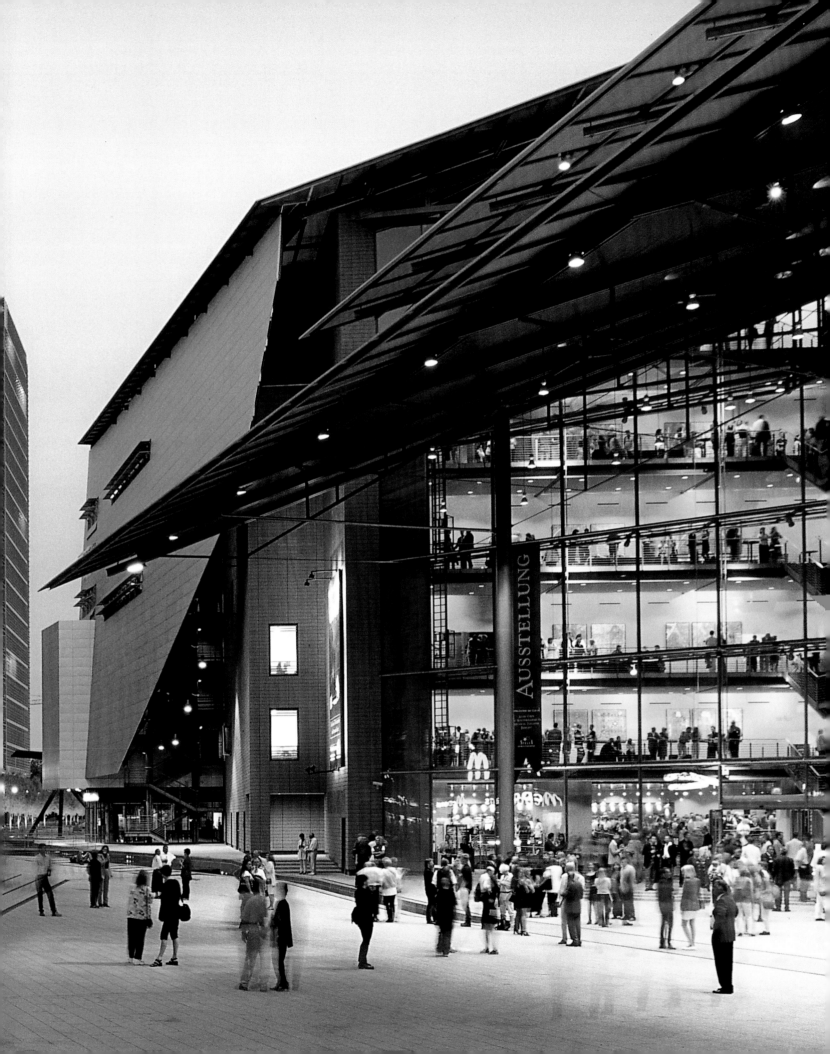

BERLIN –

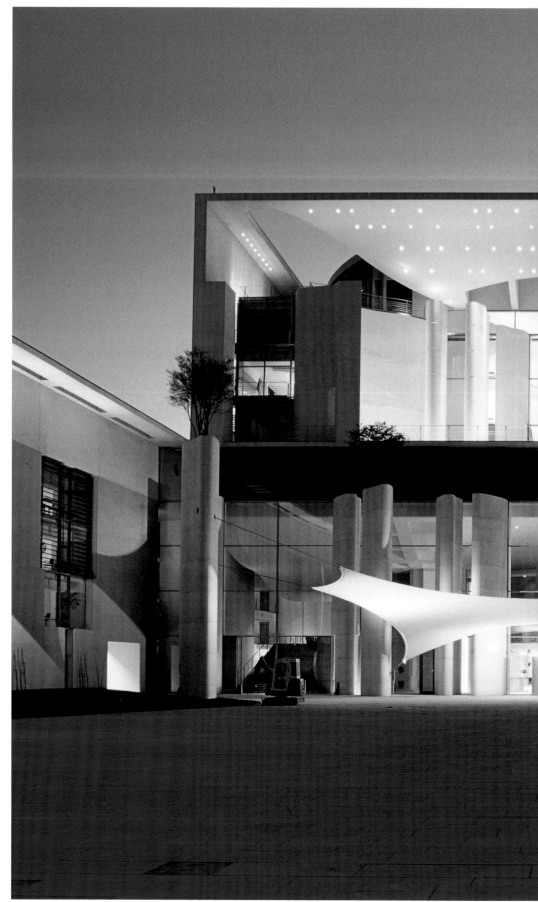

The first tenant to take up residence at the colossal concrete Kanzleramt squatting between the River Spree and Moltkestraße was the German chancellor Gerhard Schröder in

May 2001. Next to it is the marginally less weighty metal sculpture by the Basque artist Eduardo Chillida, sporting the apt and perhaps predictable title of »Berlin«.

The step from one extreme to the other is often not very large. In the suburb of Lübars, for example, Berlin has all the charm of a rural village, whereas at business receptions held in honour of the magnates of the economy at the Adlon in Berlin-Mitte the air is so cosmopolitan it is like parading along a Champs-Elysées or Fifth Avenue lined with red carpet. Opposites are as much part of Berlin as pandas in a zoo or a telecommunications tower at an exhibition centre. The brown-shirted terror of the »thousand-year Reich« was superseded by the ageing red dictatorship of the »Politbüro«. And the hustle and bustle of weekend shopping is a mere stone's throw from the nature conservation areas on the edge of town where for the first time in over 150 years a pair of sea eagles is now nesting.

Germany's heraldic bird, long threatened with extinction, is obviously looking to set up a home near the »fat hen« of the lavishly restored Reichstag, under whose protective wings members of Germany's parliament brood over the problems of pension reform, the transportation of atomic waste and cash scandals involving large sums of money. Daylight and an atmosphere conclusive to the exclusive debate of the chamber are provided by the glass dome designed by Britain's star architect Sir Norman Foster. Here the real sovereign power, the people, jostle for space on the spiral ramp, walking all over their political representatives and enjoying the fantastic panoramas of the city from their elevated position. Yet before they get this far they have to exercise a virtue that before 1989 was more commonly practised in the east of the city: queuing. The number

WHERE OPPOSITES ATTRACT

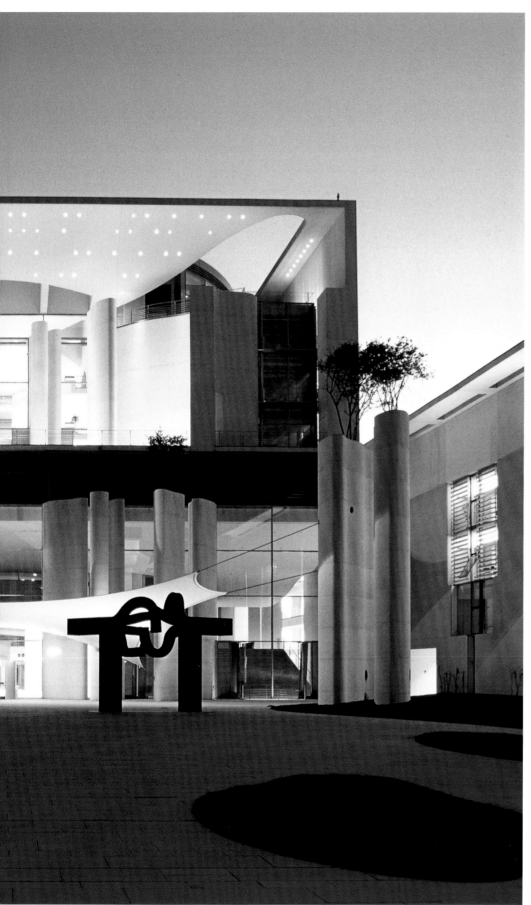

of visitors wishing to partake in this free attraction is enormous. Berlin tourists in the know come later in the evening when things have calmed down to heed the Blockade adage of Ernst Reuter: »People of the world, look at this city«.

HISTORY SEEN THROUGH AN ARCHITECT'S EYES

There are some who would have preferred the Reichstag without its cupola, the half glass egg seen as a valiant attempt to restore conditions which prevailed before 1933. The dome, it was claimed, would gloss over the dark ages of modern history and the architectural scars it left. It would appear as if the Reichstag had never gone up in flames. In the minds of the critics a parliament with a dome would not stand for democracy – ignoring the brief interlude of the Weimar Republic – but would be reminiscent of the days when Emperor William II referred to Paul Wallot's »Gründerzeit« edifice as the »national monkey house«. Remarks such as these have since ceased to be uttered. The parliament building, its old interior gutted and remodelled with an eye to modernity and functionalism, points towards the future without glossing over the past. One of the most vivid indications of this is the Cyrillic graffiti carved into the masonry by the Red Army during the battle for Berlin at the end of the Second World War. Norman Foster has integrated it into his reworked Reichstag, a silent yet eloquent witness to past times.

Diagonally opposite stands the new centre of power for the head of government erected by Axel Schultes and Charlotte Frank for 465 million German marks. The white concrete fortress is known locally as the »Kohlosseum« after the man who commissioned it, Helmut Kohl. The big chief himself, however, was no longer able to install his aquarium in his enormous new office, for the first tenant to move into the generously proportioned Federal Chancellery in May 2001 – even a touch too pompous for the New York Times – was his successor Gerhard Schröder.

A place of honour in the courtyard of the aforementioned building has been allotted to a huge metal sculpture weighing 90 tons and entitled, appropriately, Berlin.

Fashioned by the Basque artist Eduardo Chillida, the two entwining rusty claws of his work represent unity; sceptics claim it is really a case of »you scratch my back, I'll scratch yours«, or, in the German idiom, of »one hand washing the other«. What the Henry Moore creation was to Bonn, the Chillida is for the Berlin republic: a common feature of media footage filmed by reporters with little else to offer the public as they wait for news from the cabinet on the top floor.

Together with the new Marie-Elisabeth-Lüders-Haus and the Paul-Löbe-Haus (accommodating the parliamentary library, MPs' offices and administration) the Federal Chancellery is part of the »Band des Bundes« or »bond of government« joined in political matrimony by two bridges across the Spree Ost and West. And it is here that we come across another juxtaposition of Berlin, that of big politicians versus the little people. For another of the futuristic architectural piles clinging to the apron strings of »Band des Bundes« is the federal kindergarten, which, much to the chagrin of the other inhabitants of the government quarter, is reserved for the use of parliamentary offspring only.

Big or small, East or West, rich or poor, the crass opposites of Berlin have always had a hand in determining the fate of the city. Like Alfred Döblin in »Berlin Alexanderplatz«, Erich Kästner describes this phenomenon in his social satire »Fabian« published at the beginning of the 1930s. Here he writes of Berlin: »In as far as this enormous city is made of stone, it is much as it always was. As far as the inhabitants are concerned, however, it has long been a mad house. The east is home to crime, the west to swindle, the north to squalor, the south to fornication, and every which way you turn you find decline.« A bleak literary portrait indeed, but perhaps one with an element of truth in it.

BERLIN-MITTE – PLAYGROUND OF THE RICH AND POWERFUL

The same goes for Kästner's detective story for kids, »Emil and the Detectives«, which is set in Schumannstraße among other places, very near the Deutsches Theater where Kästner worked as dramaturge. In the middle of Mitte, so to speak, which has

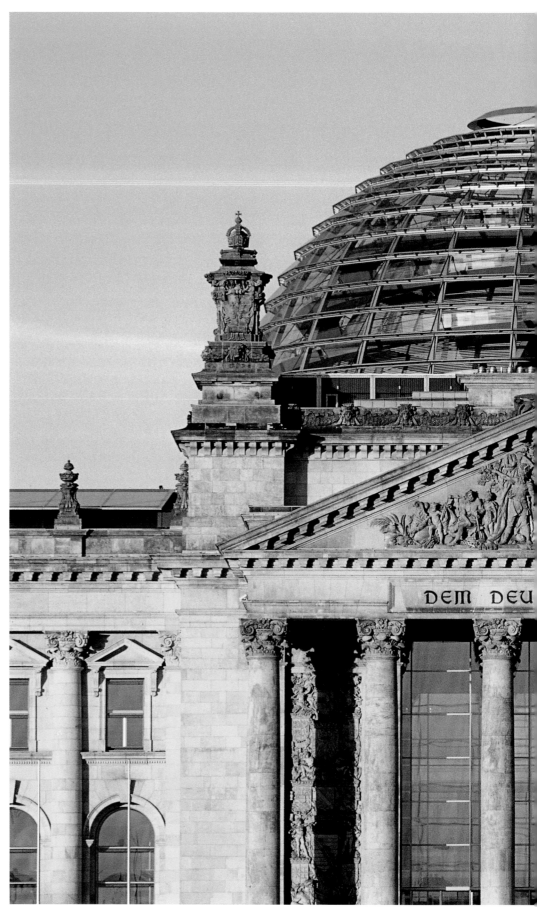

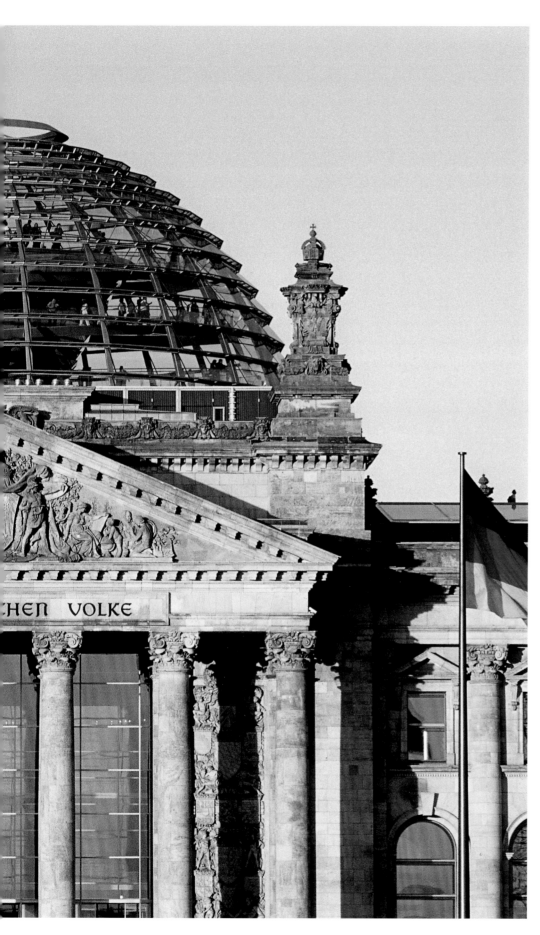

become something of a city hot spot due to both its political and diverse cultural activities. Over 150 billion marks have been poured into construction here during the last ten years to create what »Stern« magazine has termed »a playground of the rich and creative«. Once again you can feel the »metropolis pulsate«, reminiscent of the Expressionist Berlin paintings of Ernst Ludwig Kirchner, the magazine's articles enthuse. Perhaps Berlin-Mitte is the only place in Germany where Reunification has really worked. For in Mitte the Berlin Wall has even been banished from the consciousness of those who live here. Even Claus Peymann, the ever-sceptical theatre manager of the Berliner Ensemble, finds Berlin-Mitte's exposed location a good thing; he wants to use it to his advantage to turn the former Brecht-Theater into »a thorn in the arse of the government« – even if the only reason for doing so is to give his rebellious competitor Frank Castorf a rocket over at the Volksbühne on Rosa-Luxemburg-Platz.

Stoic counterpoint to the two go-getting theatre bosses is provided by the recently revamped statue of Frederick the Great who, astride his favourite steed in bronze, Condé, is totally oblivious to the passage of time. Riding out along Unter den Linden, he acts as if the torrent of cars and buses zooming past either side of his pedestal did not exist. Perhaps, in view of the incredible changes which have taken place in his imperial capital, the monarch is merely living up to his favourite epithet of »each be happy in his own way«, even if this does involve more than one horse power. Maybe in his own way Old Fritz is content too, for 2001 has been declared Prussian Year in celebration of the royal coronation of his ancestor Frederick I in 1701 with Berlin staging exhibitions, lectures and other Prussian pomp in honour of the occasion. In doing so, efforts have been made to embrace the two poles of Prussianism: the enlightened, liberal spirit of its ambitious, art-loving potentates and its sabre-rattling militarism. This is history in black and white, echoing the colours of the

Prussian flag. And the successors of the Prussian kings and German emperors? They have naturally become major players in the high society of the new German capital. From their villa Monbijou in Grunewald they do not have far to go to attend the various events on offer – much to the delight of the booming number of gossip columnists.

And at the feet of Old Fritz the melting pot of Berlin-Mitte – the ministers and managers, doers and dreamers, would-bes and has-beens – bubbles on. The predicted knock-on effect has kicked in. Even the Bundesrat, which originally was to stay in Bonn, has moved to Berlin – and taken up elegant residence in the old Prussian palace on Leipziger Straße ...

AN AURA OF ARTISTIC DEPARTURE

The rich and beautiful rendezvous is at the posh restaurants poised around Schinkel's former Schauspielhaus on Gendarmenmarkt, heralded time and again as the most exquisite square in Berlin. When at the theatre Gustaf Gründgens asked the question »To be or not to be?« maybe he already had an inkling that his state theatre would not survive the Second World War. Following renovation during the GDR, era the theatre was reopened as a concert hall and is now used for formal state festivities or as a backdrop to the Goldene Kamera award ceremony. The temple of the muses is flanked on both sides by the German and French cathedrals, buildings which also rose from post-war ashes to new-found glory. Where Gendarmenmarkt, watched over by Schiller, effuses an aura of truth, good and beauty, a few streets further on the area around Auguststraße, Tucholskystraße and Oranienburger Straße smacks of artistic departure with its many galleries and of the carefree life of the Bohemian with its numerous pubs and clubs stretching from the old synagogue to the Hackesche Höfe. When after dark the ladies of the night move amongst evening strollers in search of business on the horizontal and the red lights of the Television Tower on Alexanderplatz twinkle against the dark blue sky, it is like being transported back to the days when George Grosz made his inimitable study of the demimonde and Döblin confronted his character Franz Biberkopf, fresh out of jail in Tegel, with the biting reality of Berlin.

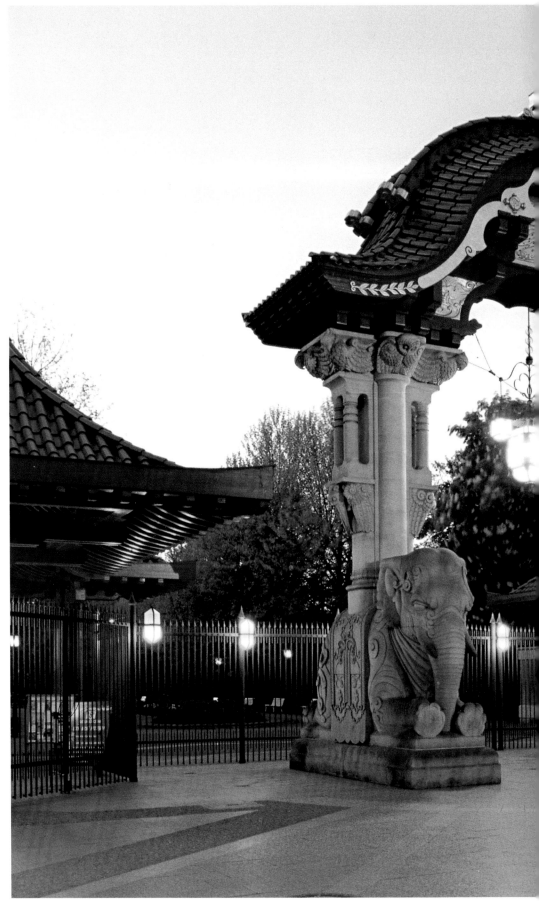

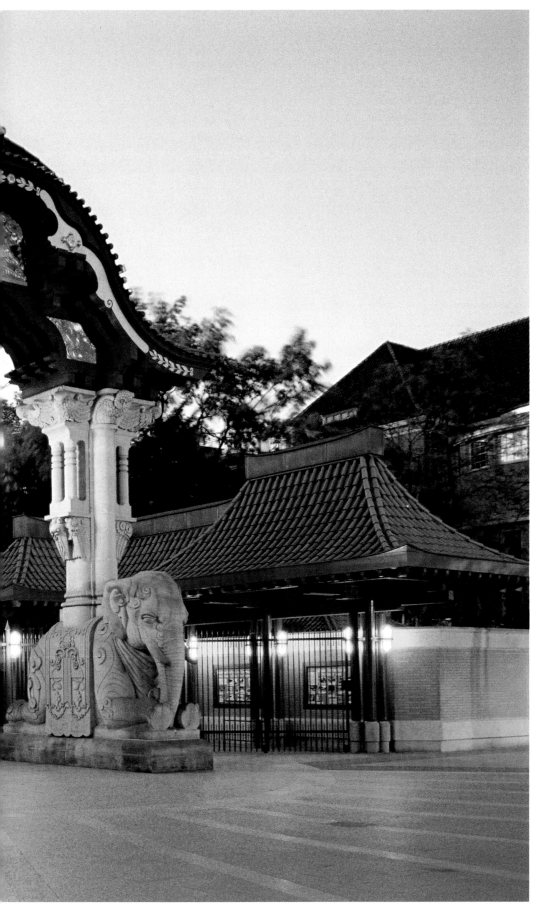

Yet another side to Berlin-Mitte presents itself in the two halves of Friedrichstraße. North of Unter den Linden the street is a giant arts centre, to the south a consumer's paradise. Heinrich Heine went into raptures about the thoroughfare as long ago as in 1822 in his »Letters from Berlin«; Friedrichstraße exemplified »the notion of infinity«, he wrote. Today Heine's infinity can be found in the endlessly long legs of the girls dancing at the Friedrichstadtpalast, in the infinitely hilarious cabarets staged at Die Distel or during various pop and party events which await punters at the Tränenpalast on Friedrichstraße station, where until 1989 journeys to and from the two halves of the divided city usually ended in eternal tears and misery. Shopping in the glass glacier of Jean Nouvel's Galerie Lafayette or in the more reserved Quartier 206, on the other hand, both at the south end of the street, make you think of something quite different – namely of the clearly finite capacity of your wallet.

Yet despite the quickening pace of life in Berlin-Mitte, its urban heart was lost forever when in the 1950s the old Hohenzollern palace was blown to smithereens. Ulbricht needed a parade ground and willingly sacrificed a hated relict of feudalism to get one, despite the old palace having suffered less bomb damage than Schloss Charlottenburg in the west, long since restored. A socialist offering was erected in its place, the asbestos-riddled Palace of the Republic housing restaurants, function rooms, a disco and the chambers of the East German Parliament. It remains to be seen whether following the removal of the asbestos any bits of »Erich's lamp shop« will survive, possibly to be integrated into a new building overlaid with a façade of the old palace. For years experts have been arguing about how such an operation could be carried out in the centre of town. And as always in Germany when things come to a grinding halt, a special commission of top officials has been called into being to come up with a solution to the problem.

If businessman Wilhelm von Boddien had any say in the matter, he would scrape together the million Deutschmarks needed to rebuild the palace by selling shares in the proposed edifice. At the beginning of the 1990s, the tireless activist put a copy of Schlüter's residence up on site, painted onto plastic banners. His activities won him the support of many, among them Germany's most prominent politician, Chancellor Ger-

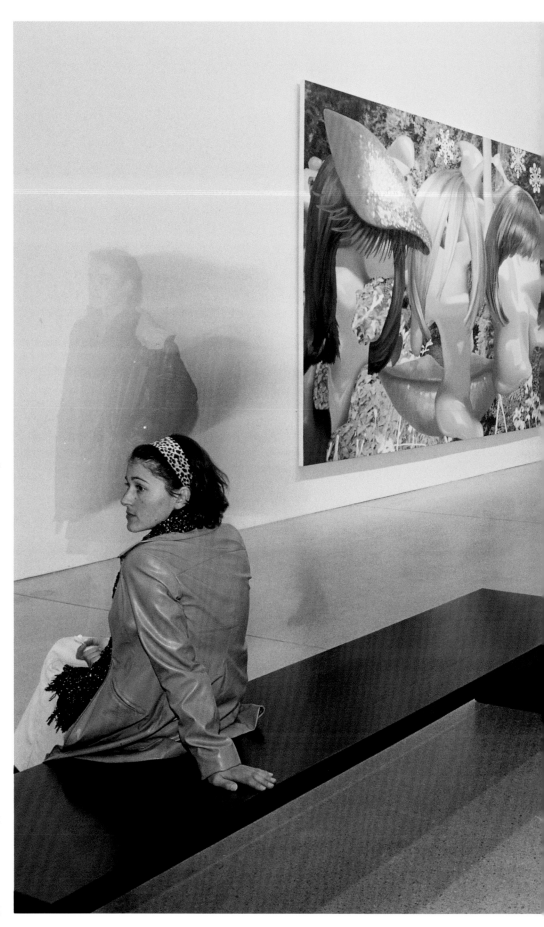

One source of pleasure for art aficionados is the Jeff Koons exhibition at the Guggenheim affiliate, housed in a branch of a major bank on Unter den Linden. The impromptu venue shows excerpts from the Guggenheim Collection in New York in a series of presentations.

hard Schröder, who up until spring 2001 gazed out onto a question mark of urban planning called Schlossplatz from the windows of his temporary Federal Chancellery in the former GDR Council of State building. The Council itself, once Erich Honecker's offices, contains one original section of the palace front. The reason is obvious: despite the palace's feudal connotations, the GDR could not face parting with the balcony from whence Karl Liebknecht called for a socialist republic in 1918.

Any speculation on the (partial) reconstruction of the palace is futile until it has been decided what the new building is to be used for. The list of suggestions includes a congress centre, a museum, a centre of the arts, civil service offices and a multifunctional complex along the lines of the Hofburg in Vienna. At the same time, what remains of the Palace of the Republic also has to be treated with the utmost sensitivity. Many East Berliners identified with the »Palazzo Prozzo«, not only because it could be used for weddings and private parties, but also because they had the chance to see pop stars such as Udo Lindenberg perform here. The Palace was also where the GDR decided to reunite with West Germany. Therefore the Chamber of the East German Parliament has been included in the list for the protection of historic buildings and monuments.

A NEW CITY WITHIN A CITY – POTSDAMER PLATZ

Has a UFO from outer space landed on the edge of Berlin-Mitte? No, that's just the glass tent roof on top of the Sony Center on Potsdamer Platz. And is that Mount Fuji, glinting green and purple in the evening light? Wrong again; that's the concertina steel-and-glass construction spanning the 43,000-odd square feet (over 4,000 square metres) of the piazza. Hot on the heels of the Daimler-Benz subsidiary Debis, the electronics concern from Japan was the second big

investor to help put Potsdamer Platz firmly back on the map, transforming what had become a haunted East–West no-man's-land into the exuberant epicentre of Berlin.

Way back in 1896 a character in Theodor Fontane's »Poggenpuhls« rhapsodised that Potsdamer Platz »... was the liveliest place. And life is the best thing a big city can have.« In 1928 the »Berliner Tageblatt« reported in one of its features on the »herds of automobiles«, on the countless omnibuses, on the people who became faceless in the crowds. At that time Potsdamer Platz was said to be the busiest square in Europe. Germany had its first set of traffic lights here, a strange contraption sporting a clock and a police platform. A replica squeezed in between the Kollhoff skyscraper and the glass headquarters of the Deutsche Bahn AG conjures up images of the hectic cities of the Roaring Twenties which inspired Fritz Lang to film his futurist Ufa epic »Metropolis« and Walter Ruttmann to compile his magnificent movie collage »Berlin, Symphonie einer Großstadt« (Berlin, Symphony of a City).

While we are on the subject of films: Together with the Potsdamer Platz Arkaden shopping centre, the hotels and the Musical Theatre, this medium is the biggest pull for the ca. 100,000 visitors flooding daily to the city within the city. The Imax cinema with its 3-D screenings and the two multiplexes, Cinestar and Cinemaxx, provide the other picture houses in town with some very stiff competition. The art of film is promoted by the Stiftung Deutsche Kinemathek and the Kino Arsenal who are supported in their endeavours by the new film museum, where robes and all the other diva paraphernalia once belonging to Marlene Dietrich are on display alongside props from the world of science fiction. During the international Berlinale film festival each February, cineastes from all over the world avidly follow the goings-on on Potsdamer Platz to see who will hoover up a Golden Bear this time round.

The sole remnant of the old Potsdamer Platz is the Weinhaus Huth building, accompanied by a few trees which once lined the old Reichstraße 1 running from Königsberg to Aachen. Former conductor of the Berlin Philharmonic Orchestra Wilhelm Furtwängler and the young Konrad Adenauer used to dine at the tavern in the 1920s, and in later years a certain Alois Hitler, a half-brother of the Führer, was employed as a waiter here.

The ornate interior of what was once the Grand Hotel Esplanade, where the emperor met with his gentlemen associates, has now been integrated into the glass showcase of the Sony Center like some nostalgic museum piece. To this end, the two storeys of the Kaisersaal weighing 1,300 metric tonnes were »translocated« in a highly complicated maneuvre; they were shifted 200 ft (60 m) from their original site using hydraulics. A different procedure was applied to the breakfast room; this was dismantled into 500 pieces, stored and then reassembled like a jigsaw in its new position. Even the little room the emperor sought at his convenience was saved from the old Esplanade Hotel. One local newspaper heralded it as the most beautiful gent's toilet in Berlin.

This regal environment seemed the ideal place for Josty, gâteau-makers extra ordinaire, to set up shop anew. Once the favourite meeting place of the imperial capital's cultural elite, this is where artist Adolph von Menzel had his afternoon nap, where Fontane came and went and where the Else Lasker-Schüler literary circle hung out, driven out of the chic Café des Westens because they did not consume enough. Today Josty steals the show somewhat from the Esplanade – but nobody seems to mind.

Despite these efforts the new Potsdamer Platz by Renzo Piano, Heinz Kollhoff and Helmut Jahn and Co., with its draughty, narrow streets and architectural melange which varies with the light, can not recapture the flair of yesteryear. What it has again become, however, is an effervescent centre of urban society. The giant investments will undoubtedly pay off. Debis alone built to the tune of 4 billion Deutschmarks, Sony forked out 1.5 billion and Metro founder Otto Beisheim is hot on their heels with his plans to spend a further 900 million on exclusive apartments, hotels and offices on the neighbouring Lenné triangle by 2003. When finished, his project is supposed to resemble the Rockefeller Center in New York, albeit on a slightly smaller, Berlin-sized scale. Within the same

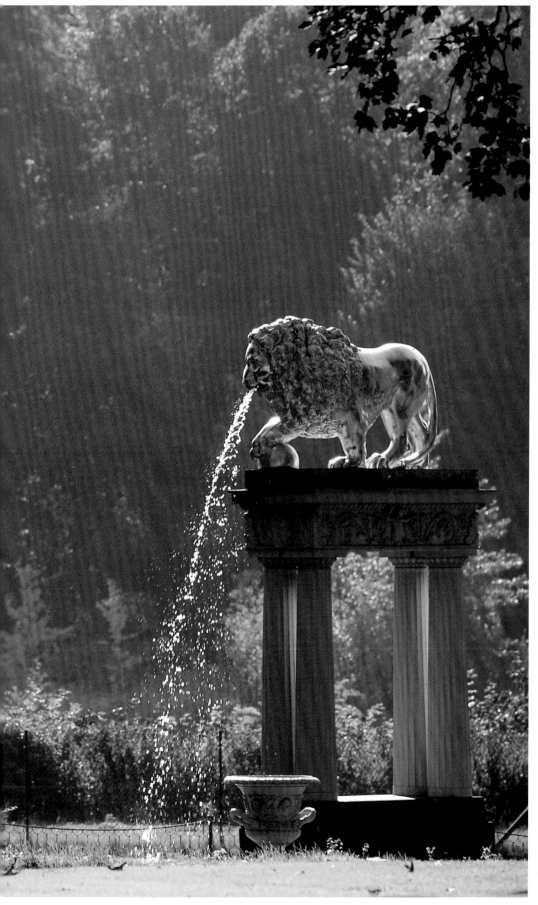

space of time the GSP group, an urban planning and project development company, is to complete the last section of Potsdamer Platz near the Mendelssohn-Bartholdy-Park underground station – for 280 million German marks.

PLAYING MONOPOLY IN BOOMTOWN BERLIN

As if that was not enough for boomtown Berlin. On Leipziger Platz next door the game of monopoly continues. To date the only edifice to have sprung up on this piece of waste ground is the Mosse Palais. By 2004 eleven new buildings are to join it to create a smaller city quarter with a maximum height of 120 ft (36 m), the highest elevation once again determined by the powerful director of construction for the senate, Hans Stimmann. The ballet of cranes which has been dancing all over Berlin for the last ten years – and once under the baton of Daniel Barenboim, the musical genius behind the Staatsoper Unter den Linden – has not yet served its purpose.

The tourist hype surrounding Berlin-Mitte and Potsdamer Platz in particular has set new records in the hotel industry. The statistics for 2000 show that over 11 million nights were spent in 65,000 hotel beds in Berlin; that number is rising and is thought to soon beat New York. Investments are also being made in the category of luxury hotels. Haus Cumberland on Kurfürstendamm is to be turned into an Adlon of the West. And after Estrel in Neukölln, Germany's biggest hotel development with 1,200 rooms, plans are being made to break this record not far from Spandau Station. The new complex is to have 1,400 rooms, a lakeside stage in a man-made bay of the River Havel and several large restaurants grouped around a hotel tower 430 ft (130 m) high. At present this, alongside the skyscrapers planned for Alexanderplatz, is simply pie in the sky.

The general sense of departure hovering over Berlin-Mitte has left the old-established West Berliners feeling somewhat neglected. Some suspect that despite the new buildings near Café Kranzler, Kurfürstendamm is gradually becoming demoted to a suburb shopping precinct. Shop owners counter that the largest turnovers are still being made here and not on Potsdamer Platz

or Friedrichstraße. At the Deutsche Oper on Bismarckstraße, however, managers note with envy that the Staatsoper in Berlin-Mitte is better subsidised and at the Schaubühne on Lehniner Platz the young team headed by director Thomas Ostermeier and choreographer Sasha Waltz is hard pushed to match the spectrum of cultural activities on offer further east. The old state theatre in Charlottenburg, the Schiller-Theater, which closed down in 1993 and was where stage greats such as Heinrich George, Bernhard Minetti and Samuel Beckett once caused a stir, stands as a monument to stagnation, symptomatic of much in the old West. Similar to Kreuzberg, which can no longer hold a candle to the new scene raving across Prenzlauer Berg, Charlottenburg and Wilmersdorf are fading more and more into oblivion. One possible indication of this is the decline of the café culture on Kurfürstendamm. Institutions like Möhring are disappearing and the sorry remains of Kranzler simply defy description. However, there are signs of a new trend emerging; the long abandoned Theater der Freien Volksbühne in Wilmersdorf has become home to the Berliner Festspiele and, in the belief that life is better out on the Lietzensee and Schlachtensee lakes, people are moving west – despite the considerable strain on their wallets.

BERLINERS ON THE U- AND S-BAHN

And the Berliners themselves? Gerhart Hauptmann claims that a woman from Berlin is »the liveliest, funniest, cleverest, wittiest, most charming, most loyal, most noble, most understanding and most beautiful creature on earth«. The exact opposite was penned by journalist Elke Heidenreich over a century later. According to her, the male version of the Berliner, »... not the one with the jam in ...« (a »Berliner« is also a doughnut!) »... but the one with the alleged big mouth who barks at you regardless of what you ask him ...« is »the worst person in the world« you could meet. The truth lies somewhere in the middle. You should best go to Berlin and find out for yourself – on the underground or S-Bahn, for example. Here we are presented with the full range of Berliners, just like in the best of Berlin's musicals, »Linie 1«, by the director of the Grips-Theater, Volker Ludwig. They are all here, from the Wilmersdorf widows to the social drop-

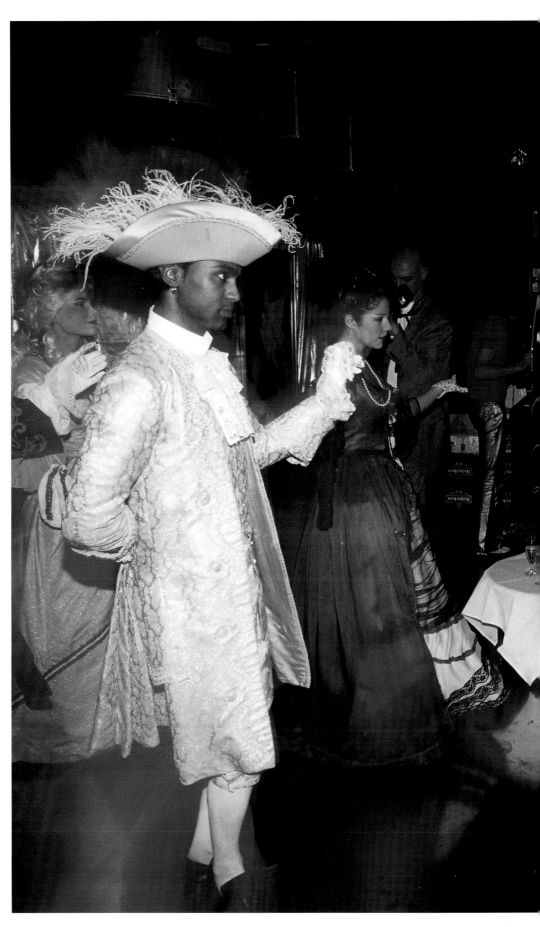

outs. Berlin's U and S-Bahn rail systems provide sociologists with a breathtakingly diverse field of study. Yet Berlin's public transport system is not just educational but also practical; you can reach almost all corners of the 340-odd square miles (890 square kilometres) of the city by bus and train. »Just the ticket« beam the ads posted by Berlin transport's PR office. Their latest coup is a collection of underwear by young design students which sport the names of certain stations. The Schöneberg bra (which literally means »beautiful mounds«) and Gleisdreieck (»triangular junction«) knickers are particularly popular with the ladies. The passion killers Jungfernheide (»old maid's scrub«) also yield high sales figures. Hits with the men are Rohrdamm (»rod street«) and Krumme Lanke (»bent waters«). The manufacturers can hardly keep up with production. This is hardly surprising; abandoning yourself to Berlin and letting it grab you by the … er… horns has always been a sensation not to be missed…

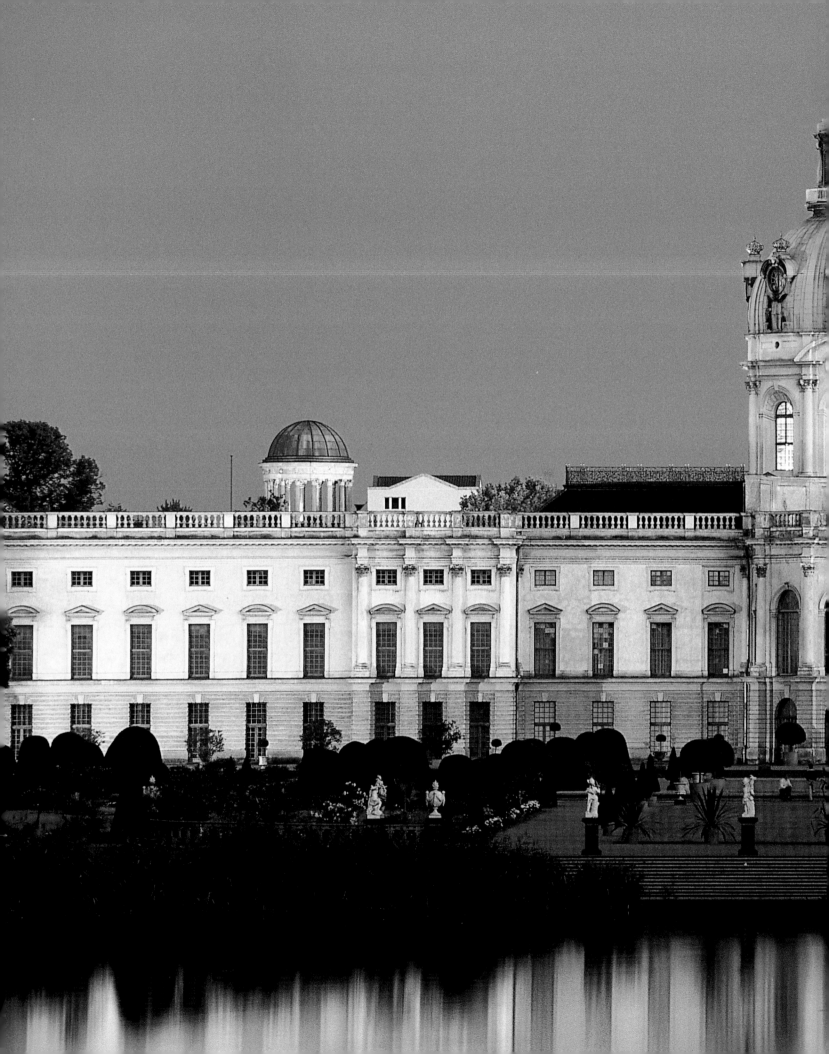

Nightlife on Pariser Platz. In summer roller skaters regularly rendezvous for Blade Night and whiz their wacky way through the centre of town, forcing drivers of less agile forms of transport to make long detours.

The cheapest way to get hooked on Berlin if you are new to the city is to take a trip on the 100 bus from Zoo Station to Alexanderplatz. In just 30 minutes the big yellow people carrier speeds from City West to City East, passing all the major tourist highlights along the way. If you are lucky you might even get one of the drivers employed by Berlin's public transport system (the BVG) who provides a running commentary on the attractions unfolding to the left and right of you. Obviously the best seats up at the front of the top deck are quickly taken. If this is the case, simply get off at one of the stops where things look interesting and explore on foot; peer through the gates at Schloss Bellevue, for example, and spy on state guests expected at the residence of Germany's federal president. One stop before this, Victory Column offers you the chance to get some exercise. If you manage to climb the 285 steps of this martial monument to the top you can gulp down the Berlin air so profusely lauded by Paul Lincke and enjoy the bird's-eye views of Tiergarten and the cityscape surrounding it. Other main points of interest along the bus route are the government quarter, the Brandenburg Gate, the magnificent avenue of Unter den Linden with its spectacular buildings, such as Schinkel's New Guard House, Humboldt University, Berlin Cathedral in all its Wilhelmine splendour and the over 1,200 feet (368 metres) of Television Tower commissioned by Walter Ulbricht as an object of prestige. Kurfürstendamm and the ever elegant KaDeWe department store on Tauentzienstraße are not actually on the 100 route but can be investigated from Zoo Station before the tour starts. The same goes for the Hackescher Markt near Alexanderplatz, Gendarmenmarkt and reconstructed Old Berlin in the Nikolai Quarter, all of which can be reached from stops along the way. Bus 100 proved so successful that the BVG recently put on an additional route, the 200, which covers much of the same ground. Unlike its counterpart the 200 does not take in Schloss Bellevue and the »Pregnant Oyster« or House of World Culture, but instead rattles past the Culture Forum and Potsdamer Platz and chugs a good 20 minutes on past Alexanderplatz to the GDR prefabs near the Jewish cemetery in Weißensee.

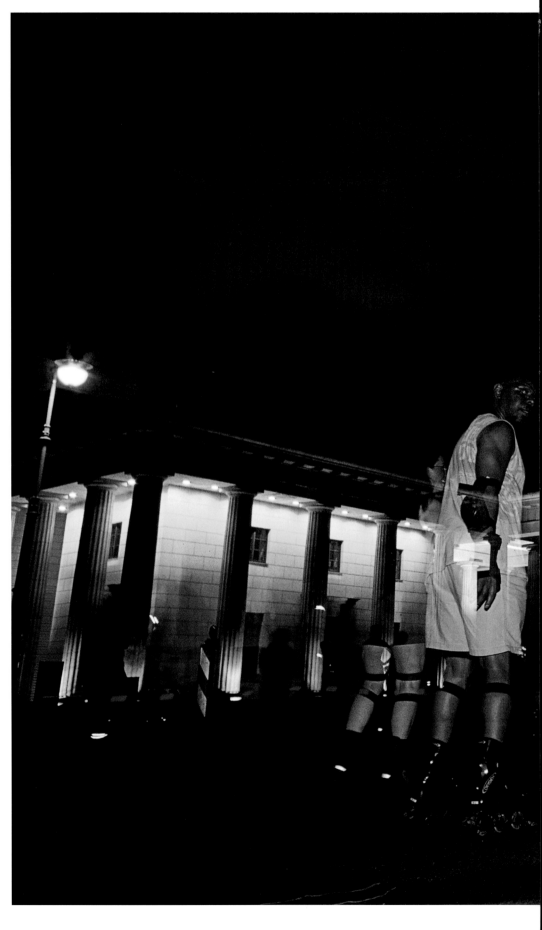

CITY EAST – AND BACK ON THE 200

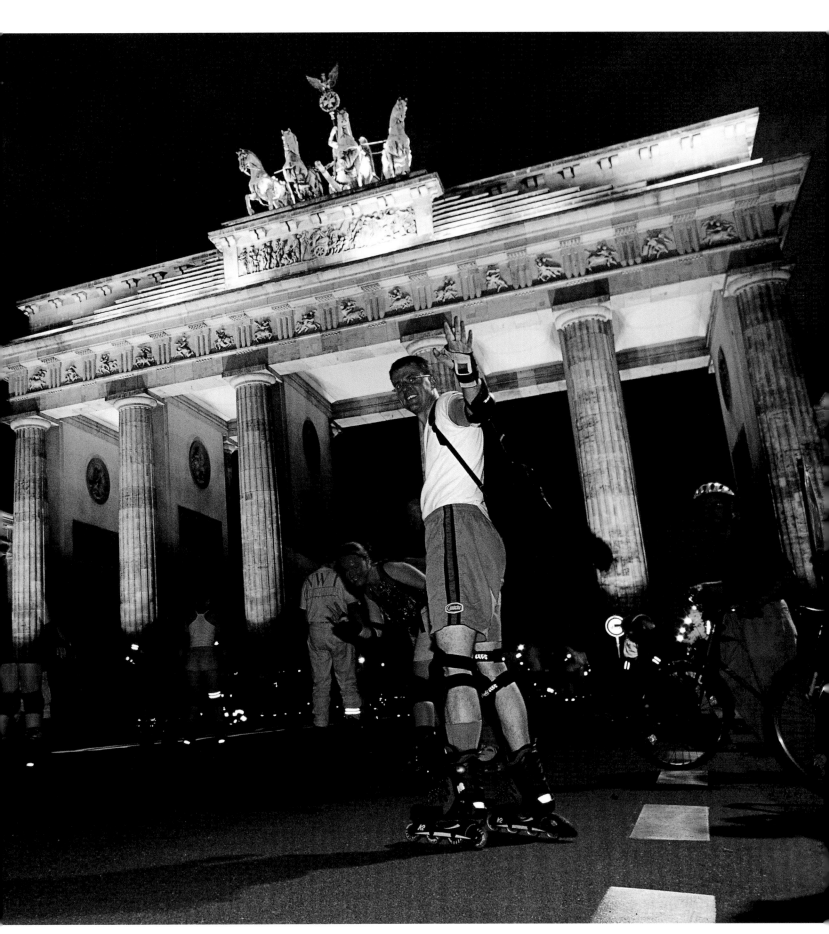

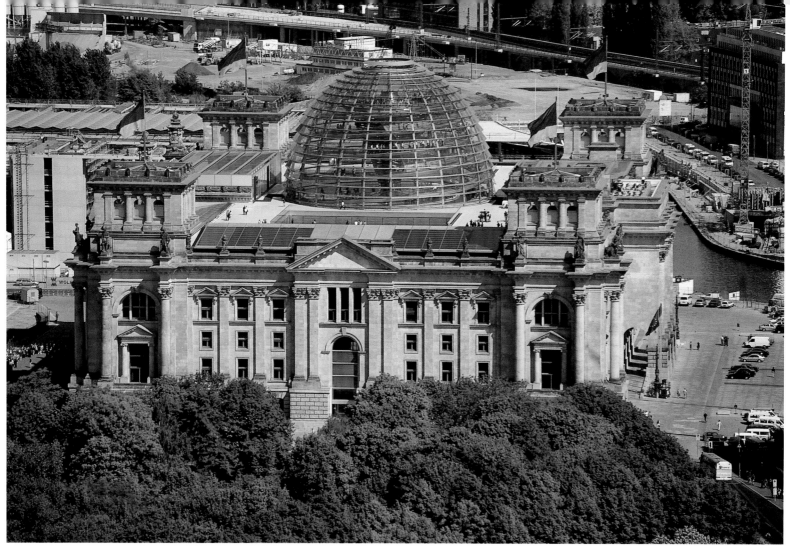

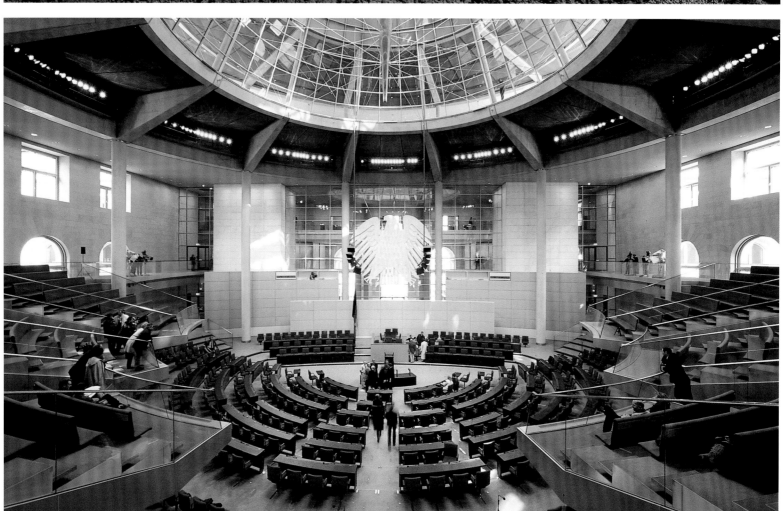

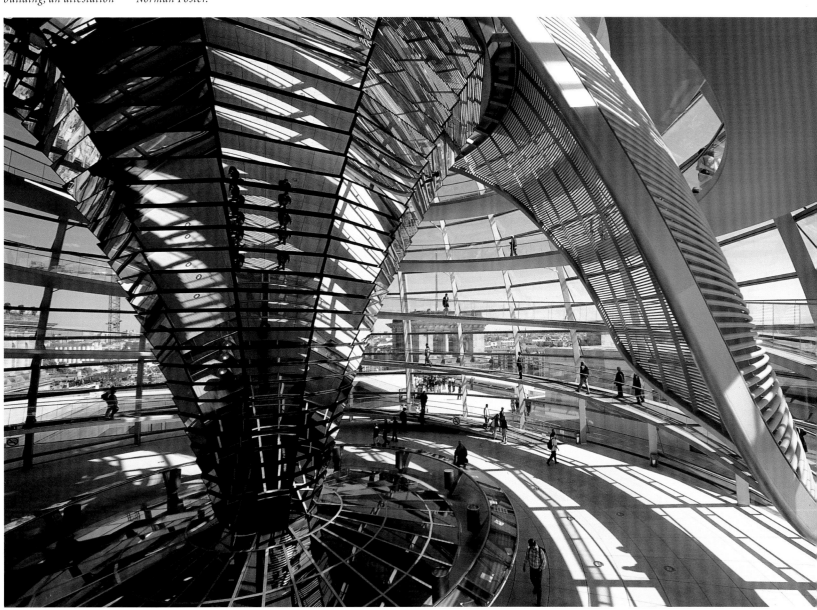

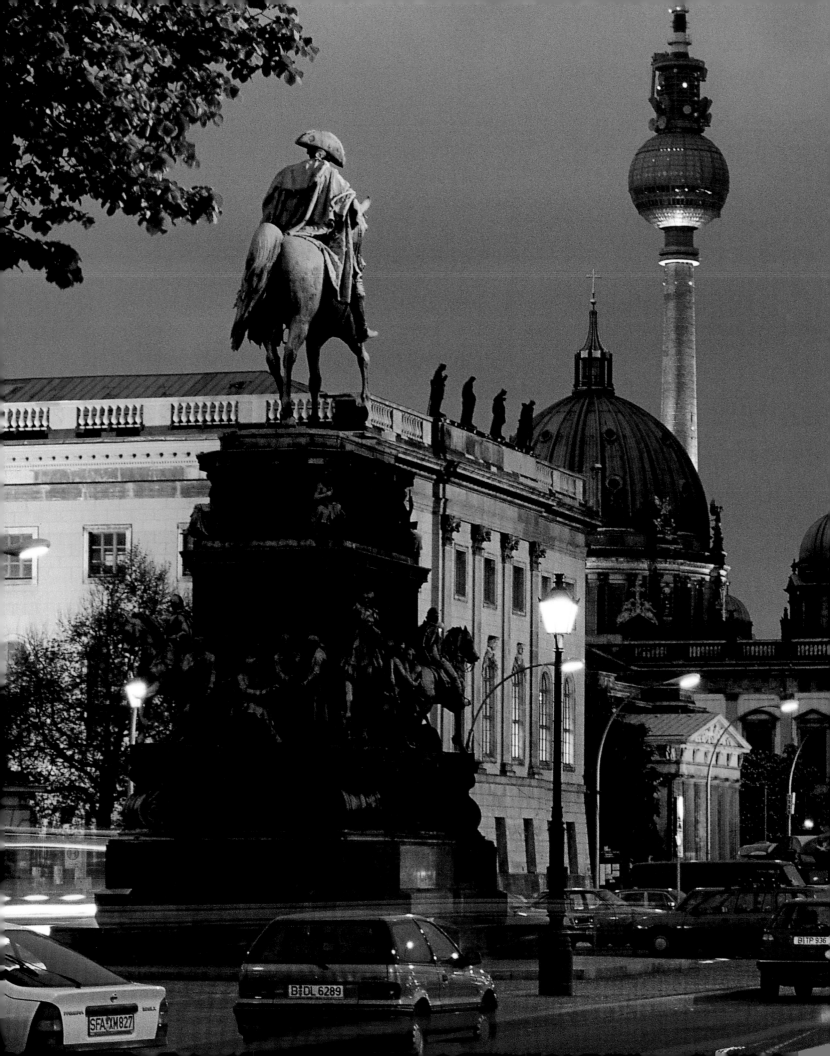

Below:
Break for a beer out in
the fresh air. The middle
pedestrianised lane on
Unter den Linden has
several excellent outdoor
cafés and restaurants.

Top right:
Coffee is also served
in style outside the
Opernpalais.

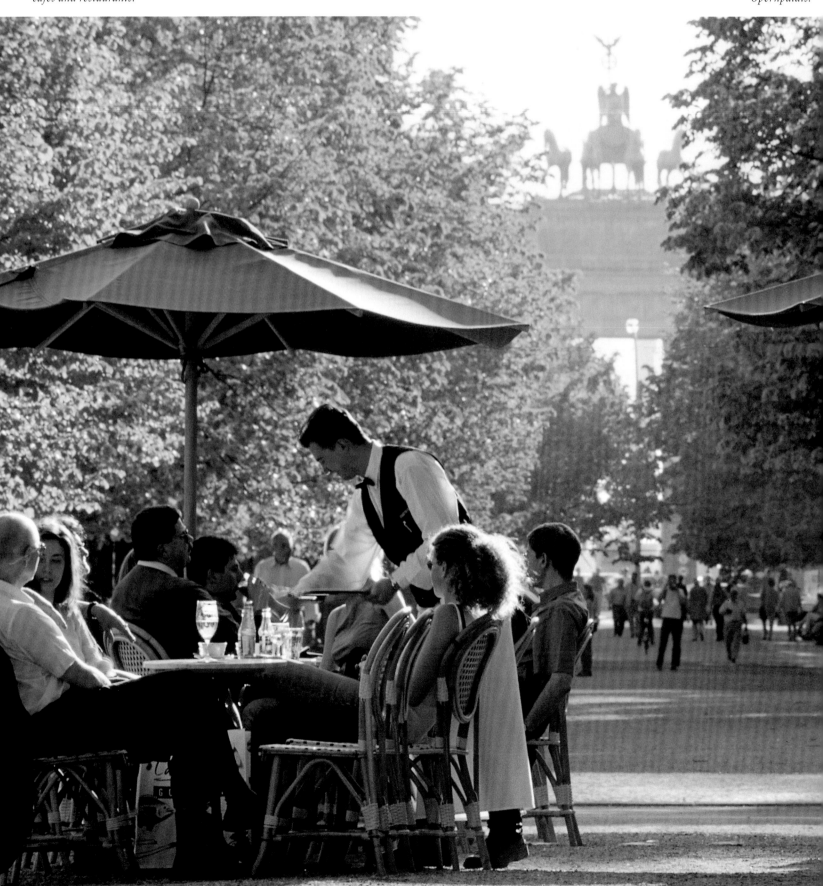

Centre right:
Nicholas I had the Russian Embassy redesigned in 1840/1841 for the ambassadors to the Tsar. It was the first building on Unter den Linden to be reconstructed after 1945.

Bottom right:
Pariser Platz, the showpiece of the capital obliterated during the Second World War, once again boasts one of the classiest hotels in Berlin – the famous Hotel Adlon.

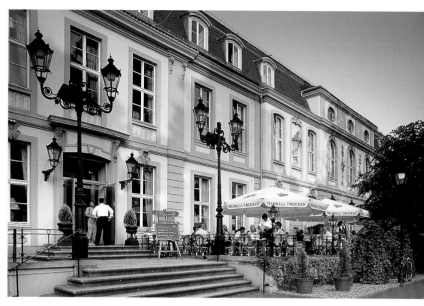

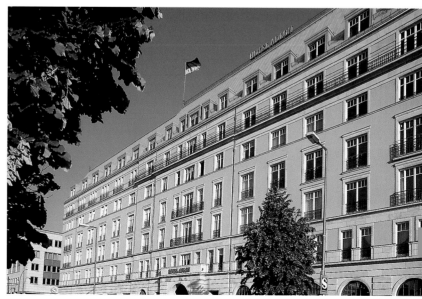

OF MEN AND HISTORIC MOMENTS

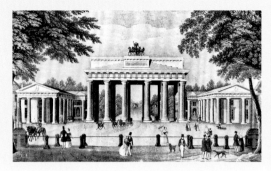

Straight down the middle is the way to walk under the Brandenburg Gate. How else? For years passage under the central arc was a privilege reserved solely for the emperor's barouche. Today entire coachloads celebrate that magic moment when their double-decker rolls under the historic portal. Of all of Berlin's landmarks, its first classical building erected in 1791 from plans by Carl Gotthard Langhans must be the most famous. It was modelled on the Propylaea at the Acropolis; as Berlin did not have enough money for marble, Langhans had the pillars whitewashed. The paint lasted a mere 13 years. In 1804 a second troop of decorators was mobilised to give it a new lick of brown paint, prompting the writer Julius von Joß to scorn that the »ideal« brilliant white had been »sullied with a disgusting café au lait«. His disdainful remarks were heeded and the paint was scraped off. Studies of the Gate made by the curators of Berlin's monuments have since revealed that over the course of history seven further coats of paint were applied, some brown, some ochre. The Gate has shown its true colour – bare grey sandstone – since 1956. This shade has become so firmly embedded in the collective consciousness that during restoration in 2000/2001 experts argued fiercely whether to keep it as the world knew it today – au naturel – or to restore it to its classical white. The grey faction won.

THE ACADEMY ON PARISER PLATZ

The intellectual disagreement over the tincture of the Brandenburg Gate was not the only dispute to rage between urban conservationists. Similar debates went on over the historicist reconstructions of the Liebermann and Sommer buildings and the flash new replica of the Hotel Adlon. Maximum heights were set and stone façades were a must. One architect, Günter Behnisch, refused to comply with directives. With the honorary president of the Academy of Arts, Walter Jens, backing him up, Behnisch's new academy building on Pariser Platz was given a glass front. This represents the transparency and open-mindedness of the edifice where Albert Speer once exhibited his model of the gargantuan Germania, »capital of the Reich«, and where later the East German People's Army installed a cell for »border violators«. Before the Nazis moved in, Max Liebermann, then president of the Academy, was required to move out and retire to his house north of the Brandenburg Gate. The ageing Jewish painter commented on Hitler's rise to power in the brash manner typical of Berlin, saying that no amount of food could replenish what he felt like throwing up.

SYMBOL OF A DIVIDED GERMANY

From 1961 to 1989 the Brandenburg Gate, cut off from the West by the Berlin Wall, was »the« symbol of a Germany divided. Neither West nor East Berliners were allowed to enter the prohibited zone of Pariser Platz reserved for border guards only. In 1987, the monument walled in behind him, ex-US president Ronald Reagan made his famous appeal to his opposite number in Russia: »Mr Gorbachov, tear down this wall. Open this gate.« Two years on the Wall came tumbling down. There have been many internationally significant moments in history like these on Pariser Platz.

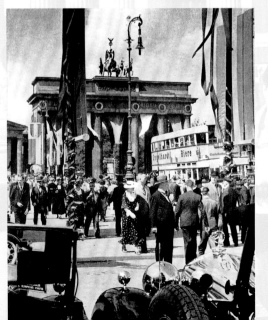

Far left:
Out and about in the 1930s, with posh motors to match the outfits.

Top left:
Artists have portrayed the Brandenburg Gate as the symbol of Berlin for several centuries (here an etching from 1844).

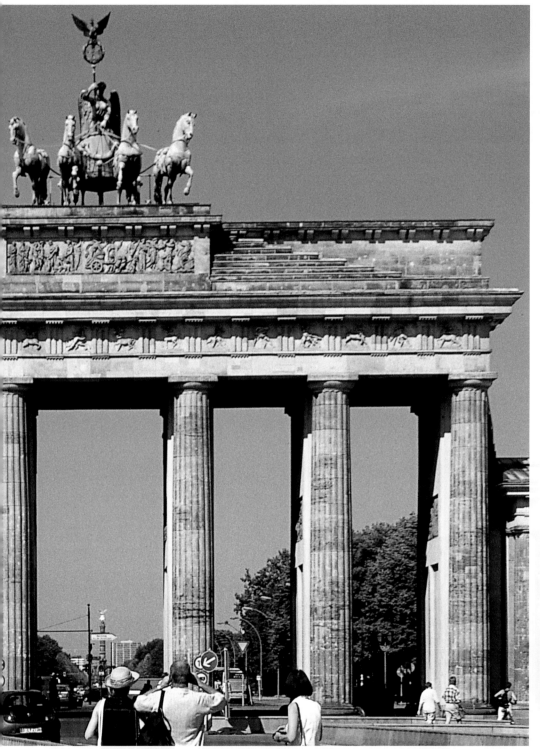

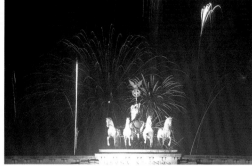

An entire monarchy of kings and emperors, presidents and excellencies have passed under this gate. Photos of VIPs genially shaking hands in front of it are obligatory footage on any kind of state visit. The building has also risen to new-found fame in the advertising industry. We are led to believe, that anything bearing the likeness of the Brandenburg Gate has become synonymous with quality.

The most expensive suites at the opulent Hotel Adlon are those which look out onto Berlin's number one monument. Destroyed by fire shortly after the end of the Second World War, the luxury establishment was reopened in 1997.

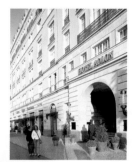

Yet the PR greats are not as up-to-the-minute as they would like to think. They were not the first to discover the marketing potential of the »genius loci«; Napoleon, for example, was one famous predecessor who used it to further his fame. In 1806 he marched triumphantly under the Gate, taking Gottfried Schadow's Quadriga with him as a souvenir trophy for the French republic. The four horses from Berlin found themselves in good company, sharing their new abode with the horses of San Marco Napoleon had »acquired« in Venice. They spent eight years away; in 1814 Blücher brought Napoleon's booty back home to the Spree. Thus the Quadriga earned its nickname of »return coach« or »retribution« (Retourkutsche). Since 1958 a copy has adorned the Gate.

Above:
The Brandenburg Gate is a must when you are in Berlin. Modelled on the Propylaea in Athens, Germany's sandstone symbol of Reunification was built between 1788 and 1791.

Top right:
The giant New Year's Eve party at the imposing Brandenburg Gate is an experience not to be missed.

Right:
Loosely based on their predecessors, Haus Liebermann (right), home to Impressionist painter Max Liebermann, and Haus Sommer were erected on either side of the Gate by Josef Paul Kleihues.

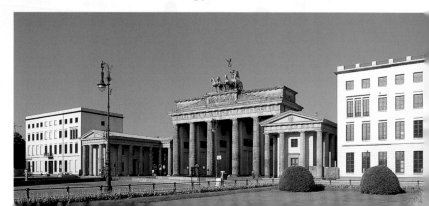

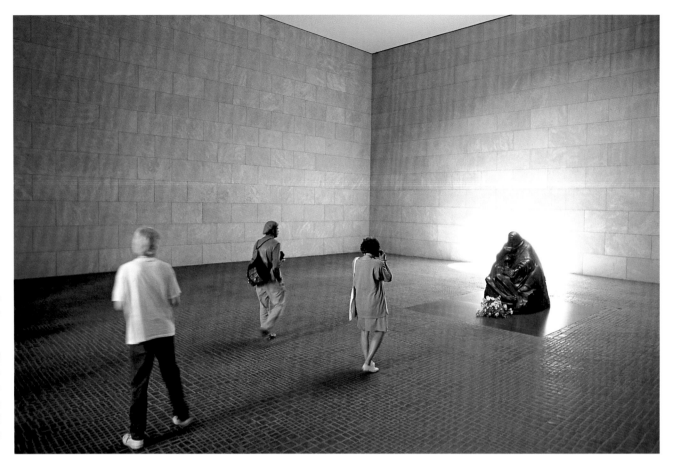

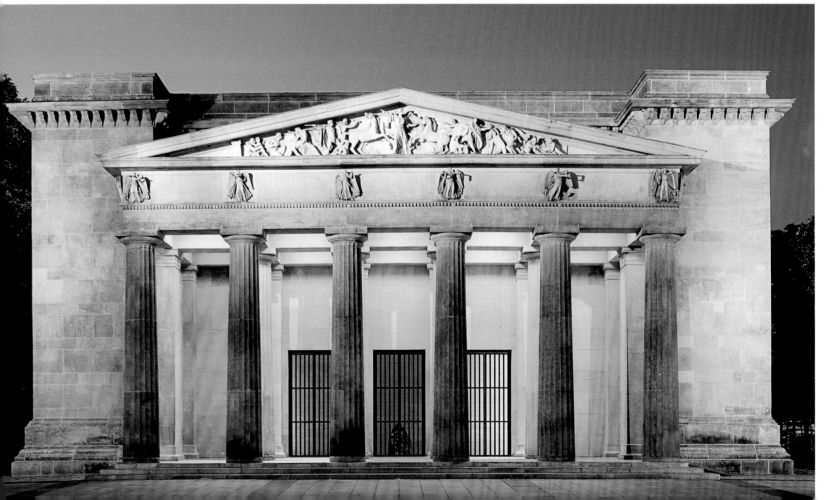

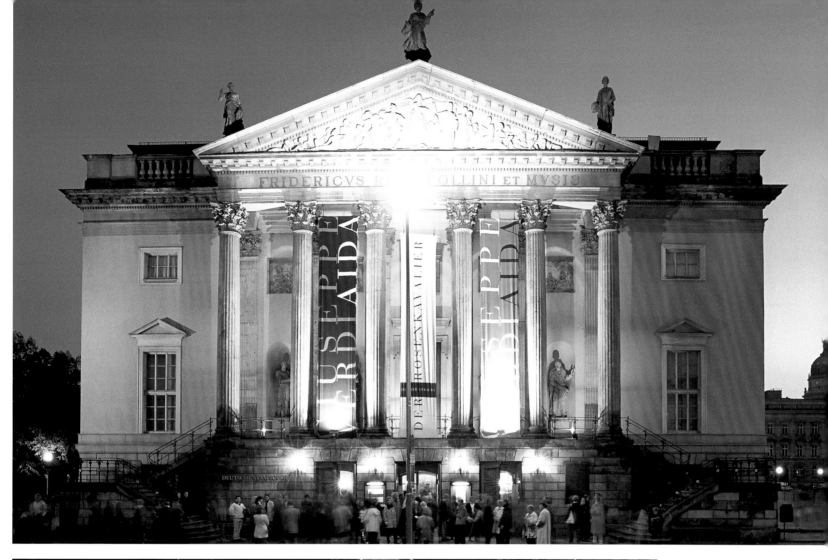

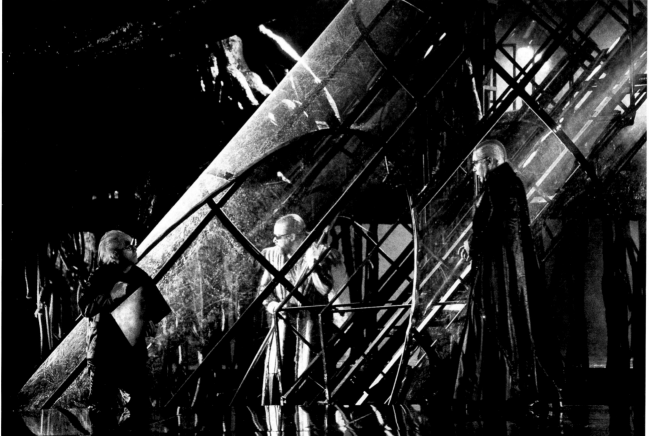

Above:
Maestro Daniel
Barenboim calls the tune
at the Deutsche Staats-
oper on Unter den
Linden. The State Opera
House is part of the
Forum Fridericianum.

Left:
The Deutsche Staatsoper
is completely sold out
when Harry Kupfer's
production of Wagner's
Ring cycle is on (here a
scene from »Rheingold«).

37

Below:

Berlin's most scenic square at Christmas time, with the German Cathedral in the background. Schinkel's

Schauspielhaus on Gendarmenmarkt, now a concert hall, once housed the Prussian State Theatre.

Right:

Praying to God under the beady eyes of the German eagle. Berlin Cathedral, completed in 1905, was the chief place of worship of the Hohenzollern family. Many of Prussia's ruling

dynasty lie buried in the vaults of the monumental edifice. The frozen figures perched on Schinkel's Schlossbrücke in the foreground pale into insignificance beneath the gigantic Television Tower.

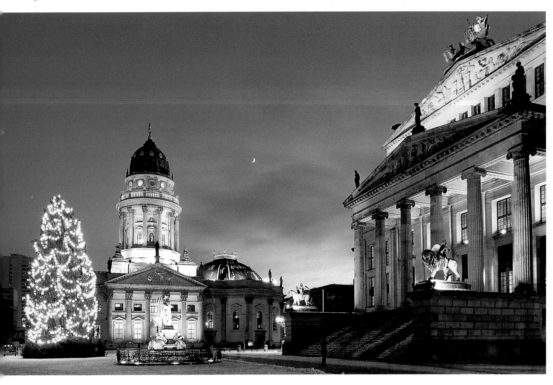

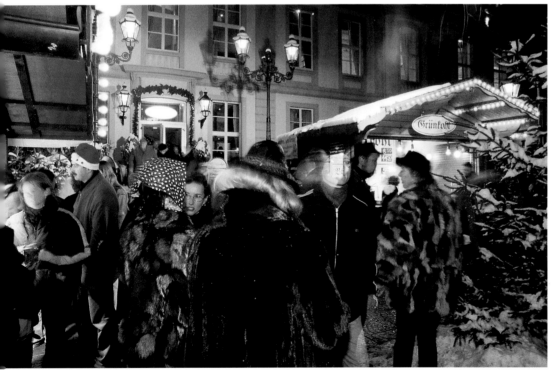

Above:

Opernpalais is just one of the places where you can browse through the stalls

of the Christmas fair, a mug of mulled wine warming your hands.

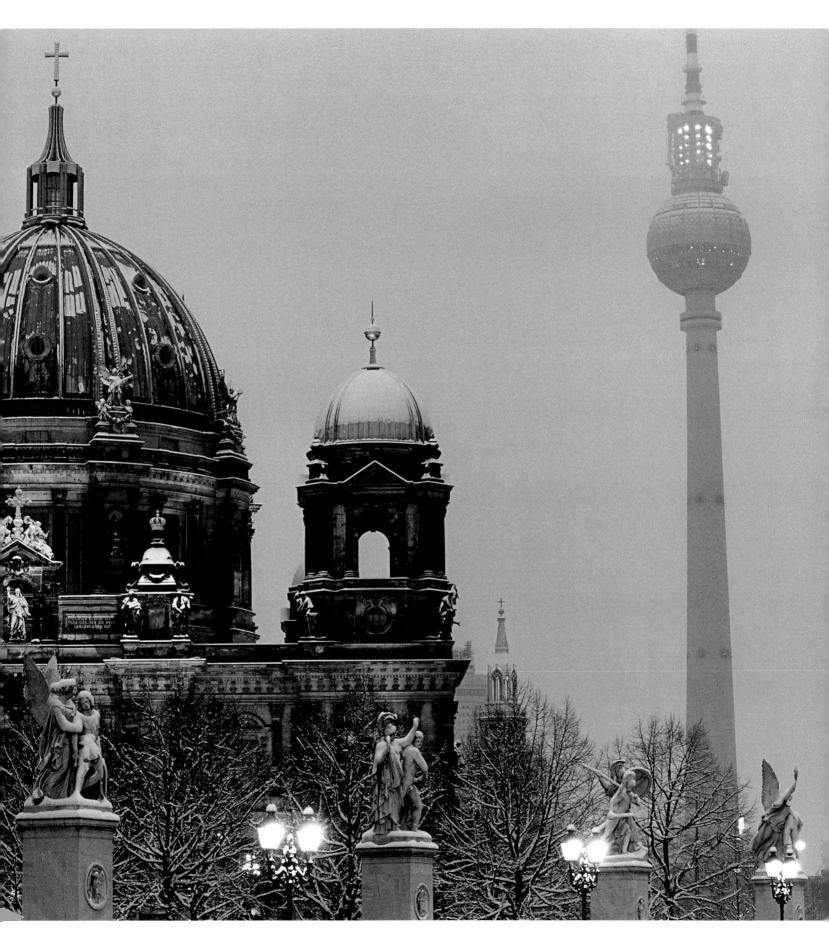

Below:
Festive lighting in the
Schauspielhaus concert
hall. Architects recon-
structing the interior

tried to recapture
Schinkel's neoclassicism.
The photo shows the
Staatskapelle rehearsing
under Daniel Barenboim.

Right:
The New Synagogue on
Oranienburger Straße
once again gleams
golden in the sunlight.
Consecrated in 1866, it
was badly damaged
during the Kristallnacht
in 1938. A brave night
watchman managed to
prevent the worst.

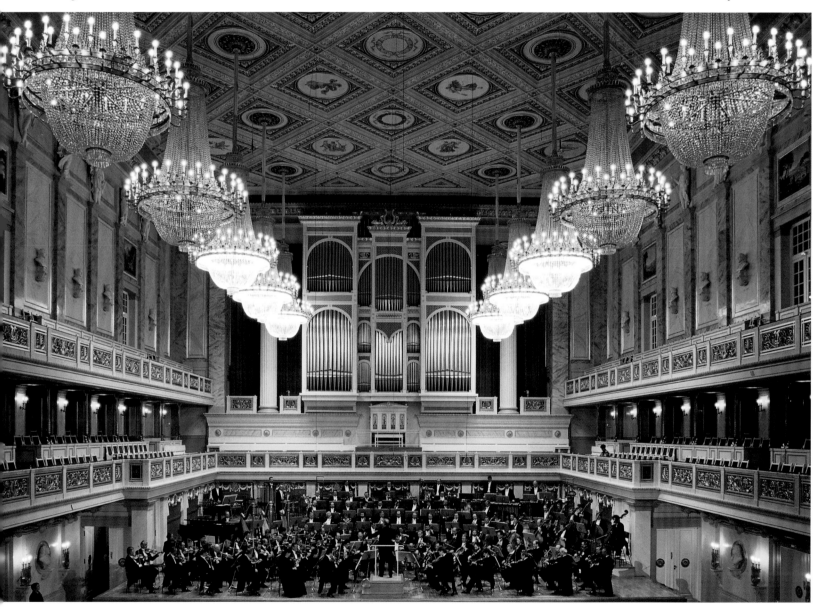

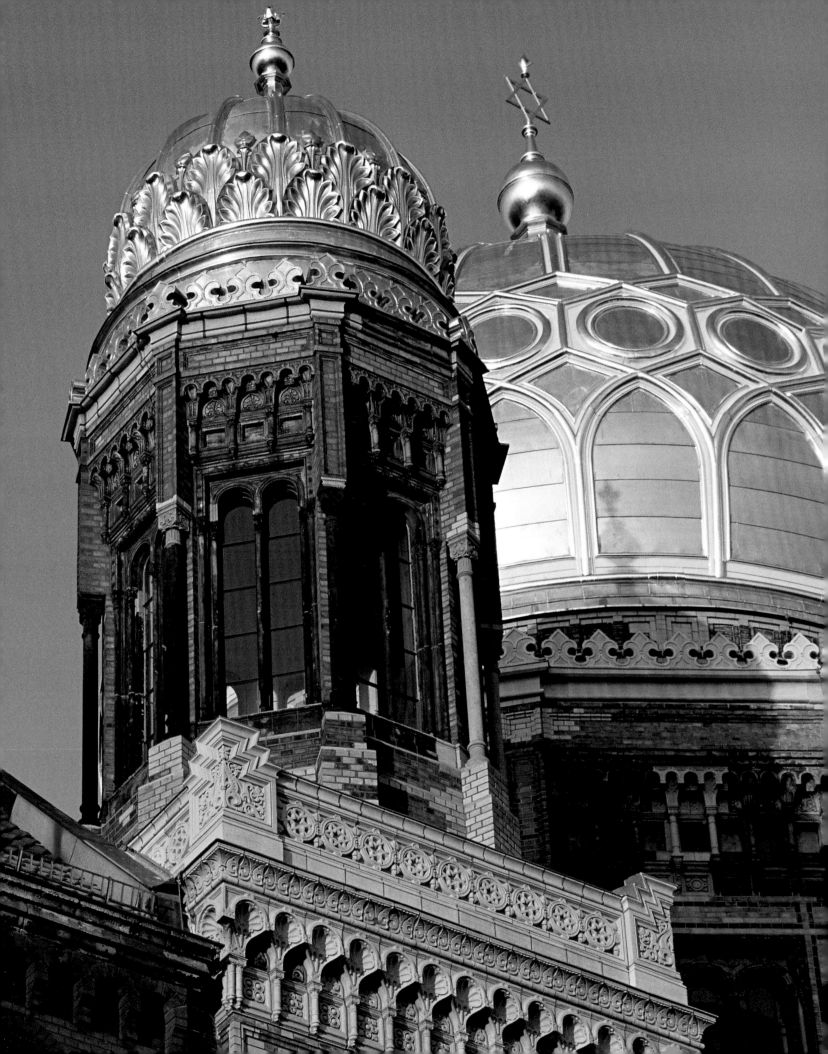

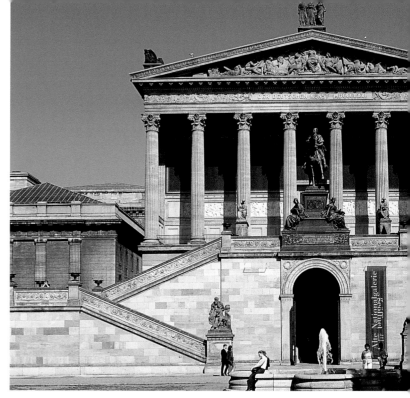

Right:
Following the extensive renovation and re-organisation of Berlin's many museums the Old National Gallery on Museum Island will be devoted to the art and sculpture of the 19th century.

Far right:
In front of the pillars lining the façade of the Old Museum, one of the most splendid museum buildings of the 19th century, an Amazon fights with a panther.

Below right:
The Old Museum on Lustgarten, built by Friedrich Schinkel between 1824 and 1829, was the first building to open on Museum Island in 1830. Berlin's collection of antiquities was moved here from the Stüler building in Charlottenburg in 1998.

Below:
Berlin is known as »Athens on the Spree« not only for its air of intellectualism, but also for its many columned buildings, such as the Crown Prince's Palace on Unter den Linden

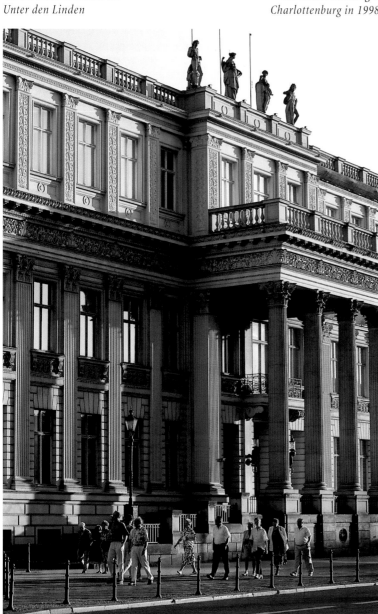

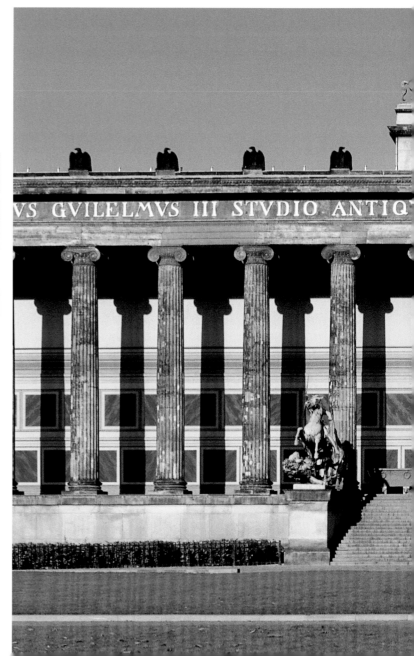

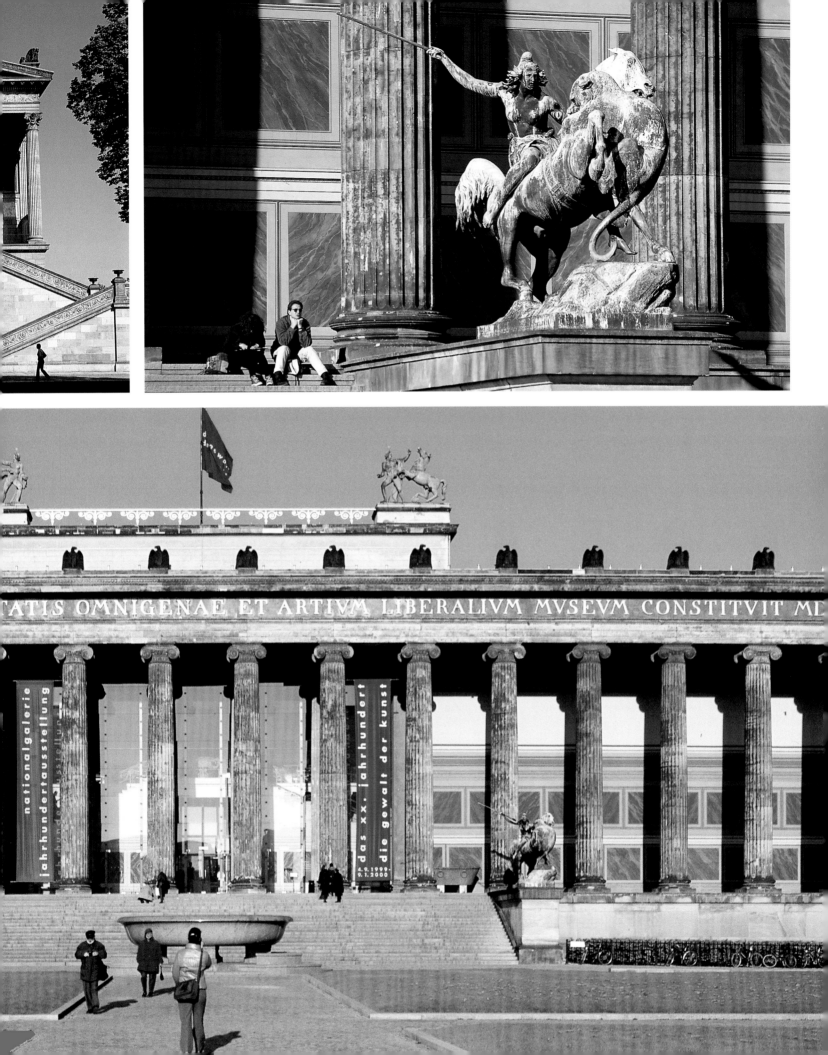

Below:
Impressions of Friedrichstraße. The American soldier by the artist Frank Thiel marks the former border crossing at Checkpoint Charlie.

Top right:
The Westin Grand Hotel on the corner of Friedrichstraße and Unter den Linden was built during the GDR period as a capitalist oasis in the East – for holders of golden credit cards only.

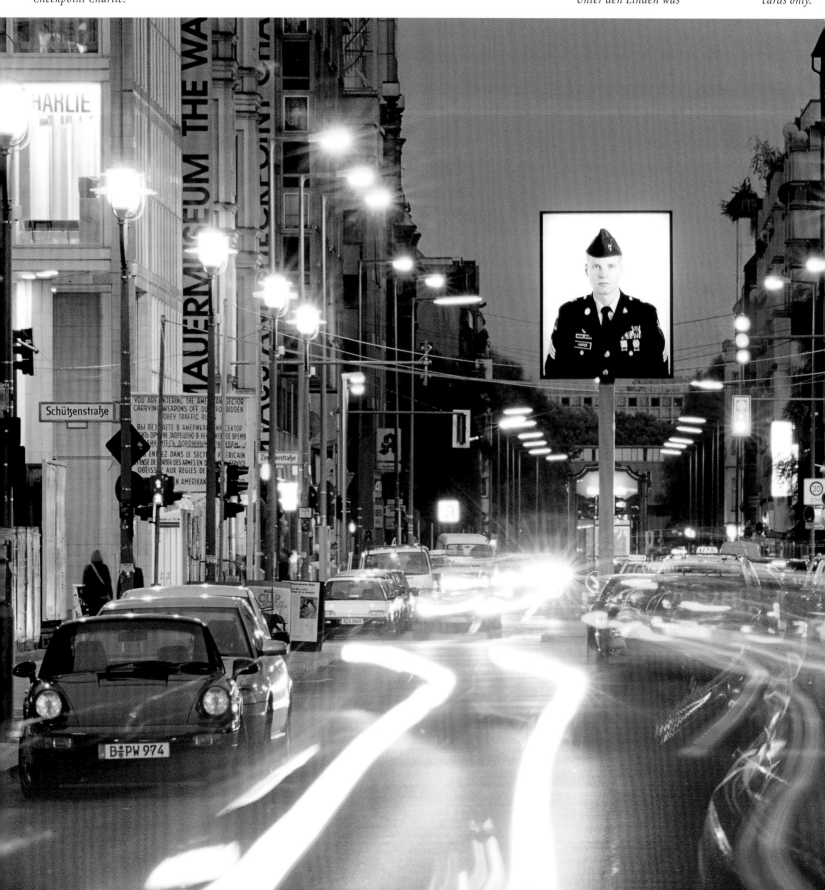

Centre right:
On Friedrichstraße
consumer's paradise
Quartier 206 has luxury
goods for purchase
and perusal.

Bottom right:
In the Berlin branch of
the Parisian Galéries
Lafayette store you

can shop in style and
marvel at Jean Nouvel's
fabulous glass funnel.

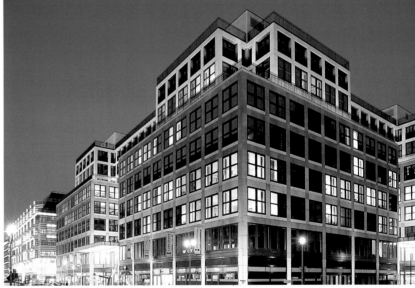

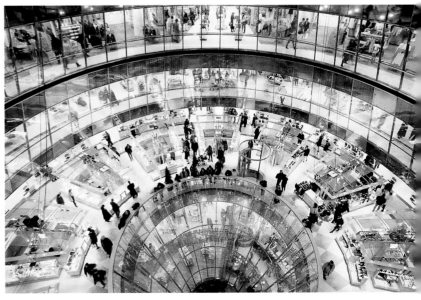

Left, top and bottom:
As here on Sophienstraße and Gipsstraße, many of the restored courtyards of old »Gründerzeit« houses and industrial complexes now nurture a booming pub and arts scene.

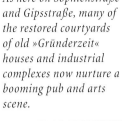

Below left and right:
One key address for the bar-hoppers and pub-crawlers doing Hackescher Markt is the

atmospheric watering hole Coffee Mamas where you can slurp a mug of freshly-ground bean.

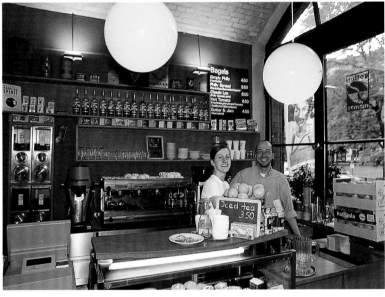

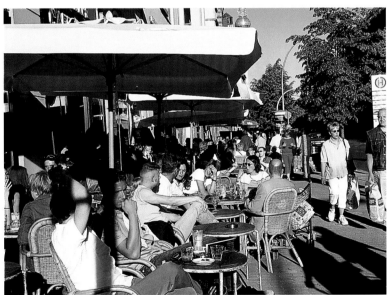

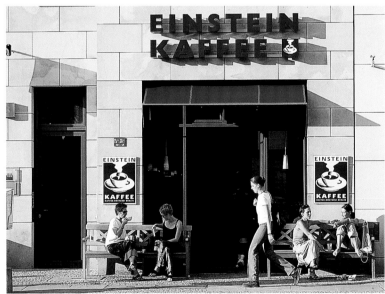

Above:
Oranienburger Strasse is a marvellous street for a stroll. The many cafés are popular meeting points for Berliners and visitors from all over the world.

Above:
The benches outside this branch of the popular Einstein Café are coveted places to watch people.

Page 48/49:
Once the largest combined residential and commercial complex in Europe, the Hackesche Höfe on Hackescher Markt have recently been completely restored. In the eight buildings

designed by August Endell and erected in 1908 as a single entity there are now restaurants, art galleries, the Hackesches Hoftheater and the Chamäleon variety theatre.

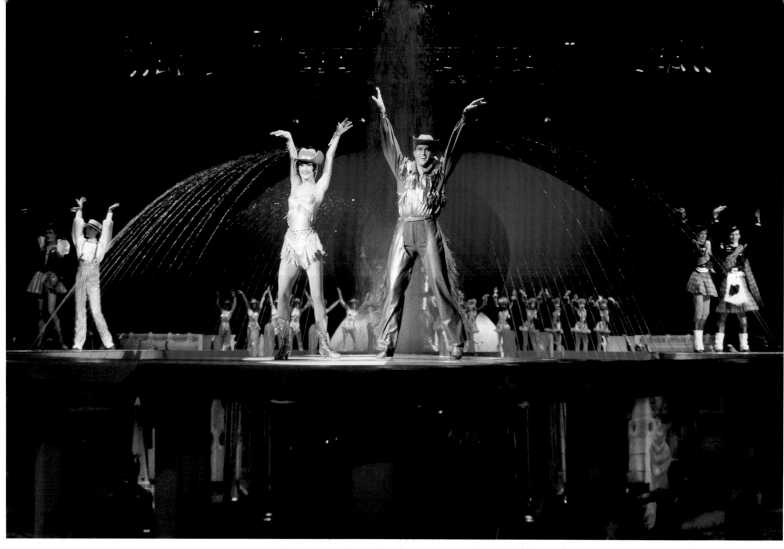

Above:
For some good enter-
tainment go to the
Friedrichstadtpalast,
where an enormous pool
can be hydraulically
raised from beneath the
stage – for synchronised
swimming.

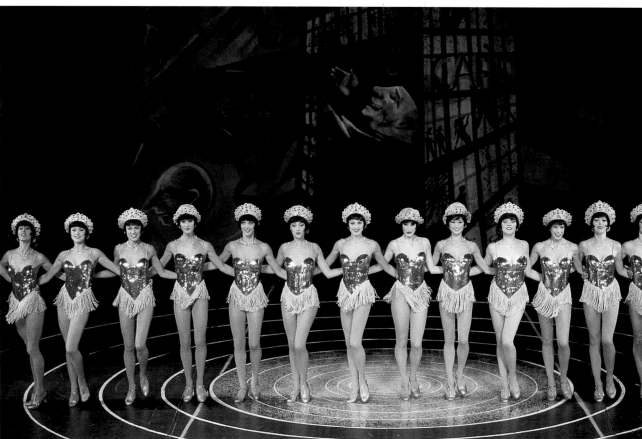

Right:
The infinitely long legs
of the dancing girls at
the Friedrichstadtpalast.
Their performance – a
cross between Prussian
militarism and sex
appeal – is one of the
highlights of the lavish
reviews staged here.

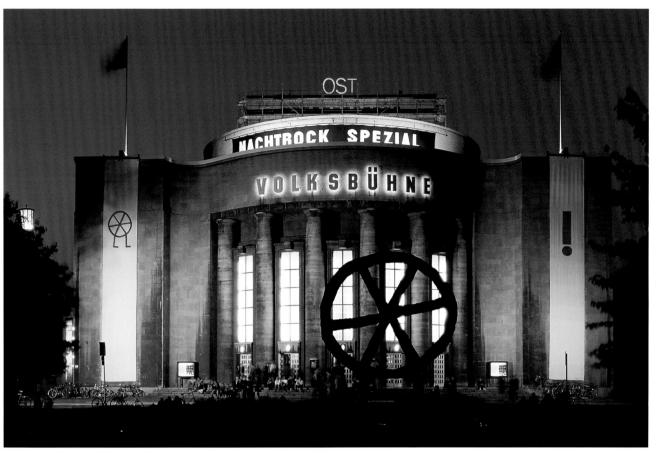

Left:
Tradition and provocation is something you will find plenty of at the Volksbühne on Rosa–Luxemburg–Platz. Here theatre manager Frank Castorf runs what is currently the most controversial playhouse in Germany.

Below:
The Berliner Ensemble, made famous all over the world by Bertolt Brecht, with a sculpture of the playwright by Fritz Cremer in the foreground. The theatre is now run by Claus Peymann.

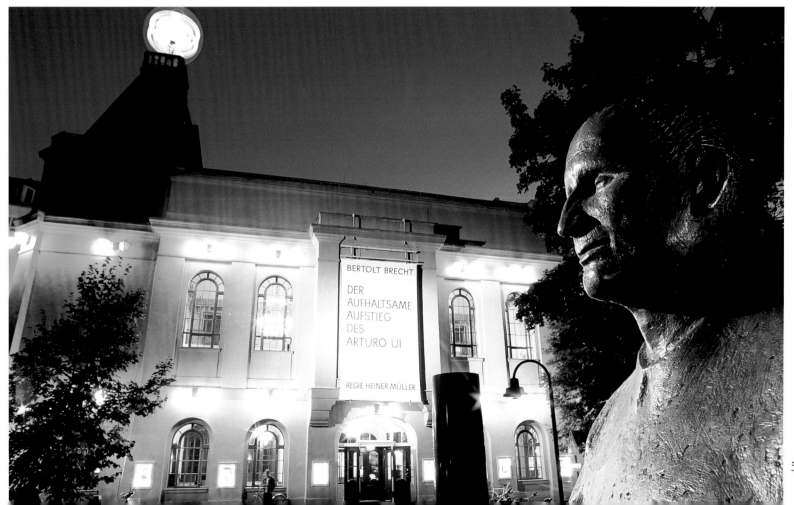

Below:

The lights of the Nikolai Quarter sparkle invitingly in the dark waters of the River Spree. The nostalgia is deceptive; nearly all of

the buildings here are new. The Nikolaikirche with its reconstructed twin spires is the only edifice still in its original place.

Right page:

As we speak, somewhere in the world there are people having breakfast, lunch, dinner or supper and the World Time Clock on Alexanderplatz can tell you where. One activity which can be

recommended whatever the time of day (or night) is a trip up the Television Tower. The ball at the top is a revolving restaurant-cum-viewing platform.

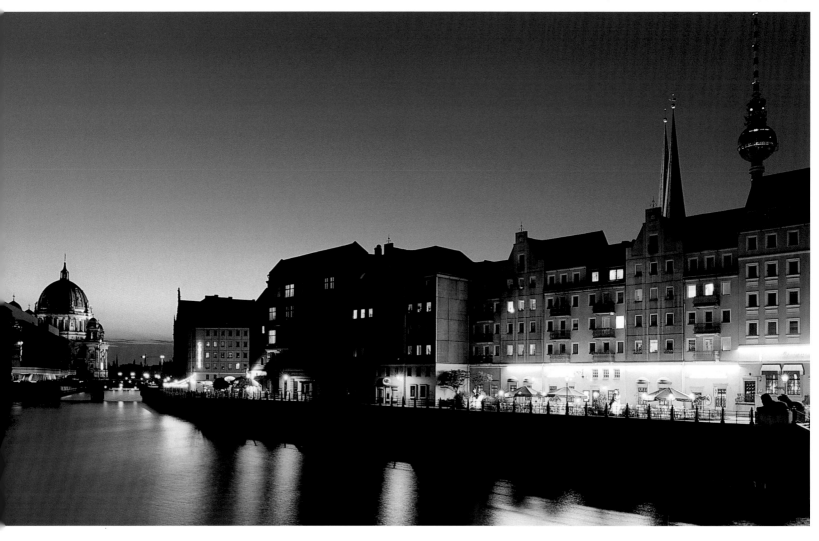

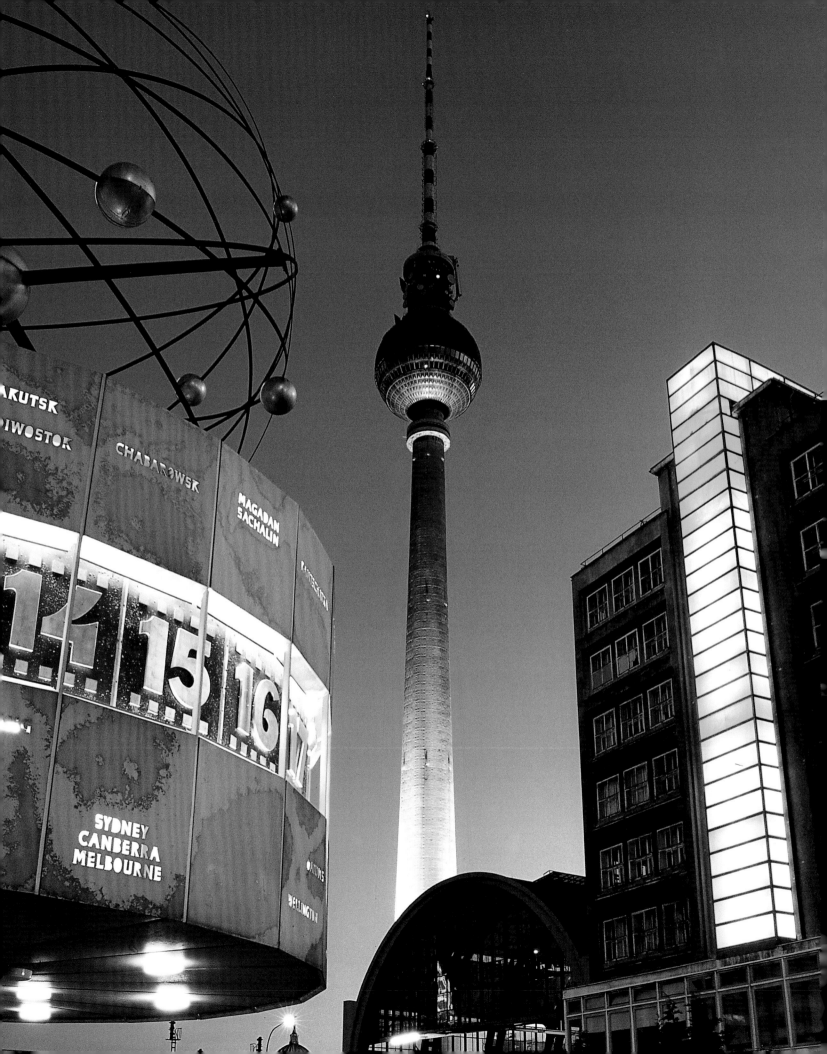

Right:
The Nikolaikirche is the oldest sacred building in Berlin. Some parts of the church at the core of the Nikolai Quarter go back to 1230, with the Gothic brick hall dating from c. 1470.

Below:
The original façade of Ephraim Palace, now used by the City Museum, has been preserved. The rococo building was once home to Veitel Ephraim, Frederick the Great's master of the mint.

Right:
Narrow streets, small shops and cosy restaurants are the trademarks of the Nikolai Quarter, constructed between 1981 and 1987. It evolved in imitation of the oldest part of the joint town Berlin-Cölln, first mentioned in 1237.

Small photos, left:
Tidy façades and tiny boutiques lend the Nikolai Quarter its unique charm.

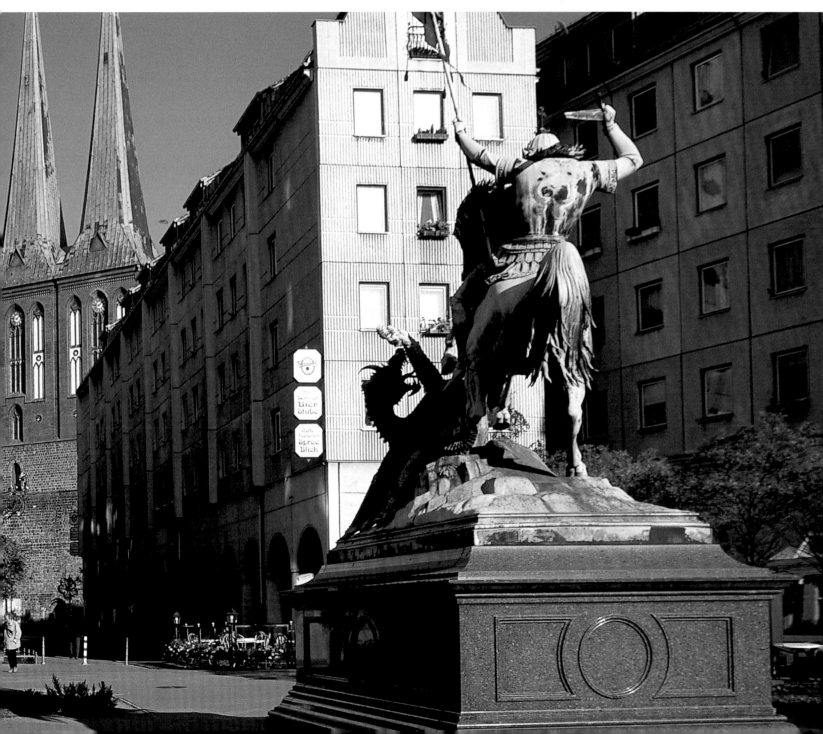

6,000 YEARS OF CULTURAL HISTORY

Whenever the Stiftung Preußischer Kulturbesitz is mentioned, the organisation in charge of a multitude of museum pieces, superlatives begin to fly. Klaus-Dieter Lehmann, president of the foundation, enthuses about »more than 6,000 years of history of mankind« creating a »cosmos of culture« at 17 museums, the state library, the state archives and a bevy of research institutes. The heart of the collection is Museum Island, built between 1830 and 1930, the five buildings of which were recently added to the list of UNESCO World Heritage Sites and are to be renovated for around two billion marks by 2010 – not all of them at once, but gradually, so that at least two museums are open to the public at any one time. Implementing the master plan is a mammoth task. Pure gold has even been invested in the operation; a percentage of the net profit made on sales of the golden Deutschmark which was minted for 2001 to commemorate the end of the old monetary system will help fund the restoration work carried out by an international team of architects. It will all be worth it; each year over 600,000 visitors flock to the Pergamon Museum alone to marvel at the Pergamon Altar (180–169 BC), the Roman Market Gate of Miletus from the 2nd century BC and the Ishtar Gate and processional avenue built in c. 550 BC in Babylon during the reign of Nebuchadrezzar II.

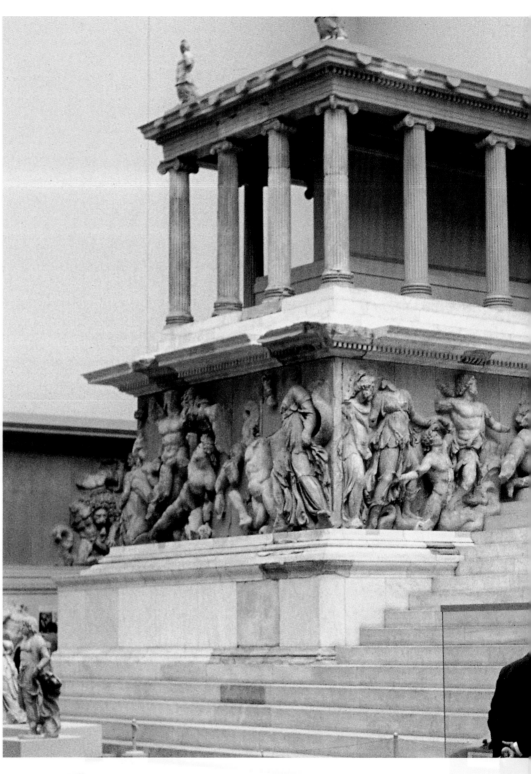

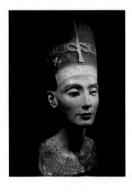

The belle of Berlin, Queen Nefertiti, is still waiting for the Egyptian exhibits to move from Charlottenburg to Museum Island. The painted chalk sandstone bust dates back to c. 1350 BC.

NEFERTITI RETURNS

The present restoration of Germany's biggest museum complex calls for a large-scale redistribution of the inventory. In Charlottenburg Berlin's belle, otherwise known as Queen Nefertiti, has her bags packed and ready to go, soon off to rejoin her Egyptian relatives on the Island. Caspar David Friedrich was quicker. He

Above:
The main attraction on Museum Island is the altar dedicated to Zeus and Athena from Pergamon in Asia Minor, now Bergama in Turkey. The altar was brought to Berlin in 1902.

Top right::
A good section of the Babylonian processional avenue built during the reign of Nebuchadrezzar II (603 – 552 BC) has been reconstructed in the Museum of the Near East, a part of the Pergamon Museum.

and his contemporaries have already turned their backs on Charlottenburg and settled into their new abode at the Old National Gallery. To compensate for the loss, Charlottenburg is to be given a new centre of photography opposite Heinz Berggruen's collection of Picassos. According to foundation president Lehmann, the future deployment of the various museums is clearly defined. The Old Museum built by Karl Friedrich Schinkel in 1830 is to function as an »educational temple« largely dedicated to ancient history; the New Museum, currently a ruin, will in future house the Egyptian exhibits and the Museum of Prehistory and Early History; the Bode Museum at the bow of Museum Island will be turned into a treasure-trove of sculptures and works from the early days of Christianity and Byzantium; following renovation the Pergamon Museum will still contain the monumental architecture of the ancient world and at the Old National Gallery the Romantics will flirt with their artistic colleagues from the 19th century.

This concept will reunite what was once one. During the Second World War Berlin's ancient valuables were stored away in bunkers and mine shafts more or less at random to save them from the bombing. At the end of the war much of the collection fell into the hands of the victors who later returned most of the booty to Berlin, scattering it between East and West. The list of missing artifacts is, however, still a long one. In 1994, for example, Priam's Treasure, excavated by Heinrich Schliemann in Troy, was discovered to be hiding at the Pushkin Museum in Moscow. Diplomats are still bartering over its return – to date with little success.

ART ON THE TIMETABLE

With the collections reorganised, the Culture Forum tucked in between Hans Scharoun's Philharmonic Hall and Mies van der Rohe's New National Gallery, erected in West Berlin after the war to replace Museum Island now lost to the East, will fulfil a new purpose. The artistic timetable of the future Modernist Exhibition Centre, inextricably linked to the Museum of the Present at restored Hamburg Station, includes Anselm Kiefer, Joseph Beuys and friends.

Another major cluster of State Museums managed by Prussian Cultural Heritage is in the Berlin district of Dahlem. Here dwell the Museums of East Asian, Indian and American

Art, the Museum of Ethnology and the Museum of European Culture. If Berlin's City Palace is ever rebuilt – or an adequate edifice installed in its place – the exhibition buildings in Dahlem may well find themselves redundant. The number of people who would like to see Berlin's significant exhibits displayed at the old Residential Palace is considerable.

Museum giant Prussian Cultural Heritage is not the only artistic institution in Berlin. There are around 150 further museums vying

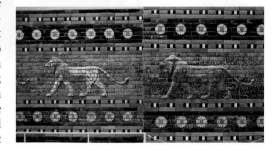

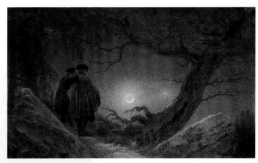

for attention. Among these are the skeletal dinosaurs at the Museum of Natural History, Konrad Zuse's first computer at the Museum of Transport and Technology, the Bröhan Museum with its collection of objects from the Art Nouveau period and many more smaller facilities such as the Anti-War Museum, the Research and Memorial Site on Normannstraße in the old Stasi headquarters and the conserved embryos of the historical medical exhibits at Humboldt University.

Centre right:
The main entrance to the Pergamon Museum. Restoration plans envisage building a glass extension on the paved forecourt.

Bottom right:
Caspar David Friedrich's painting entitled »Two Men Observing the Moon« is one of the most treasured works of art in the possession of the Prussian Cultural Heritage.

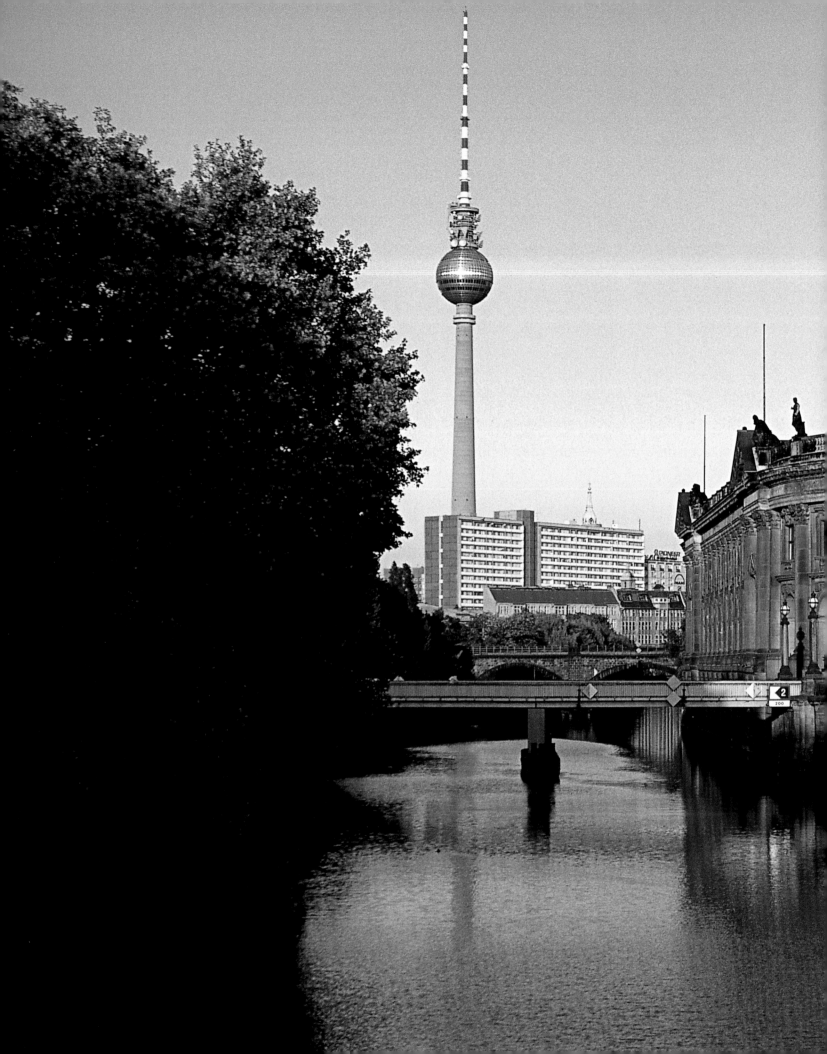

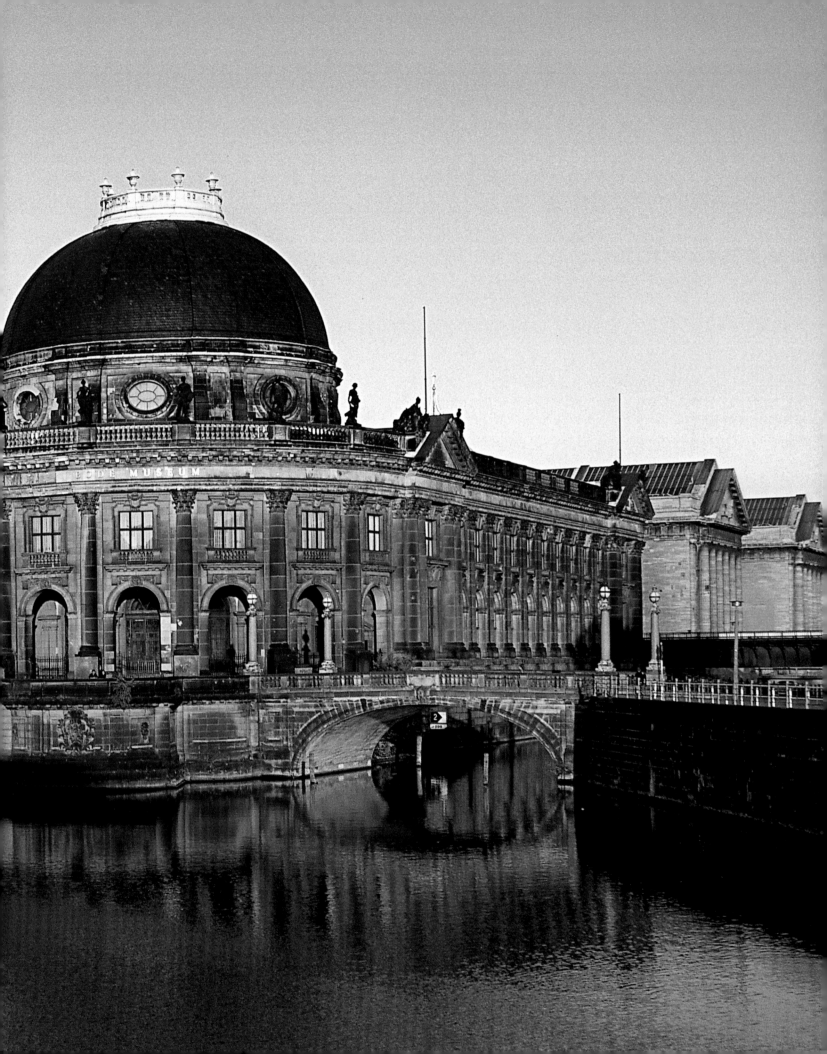

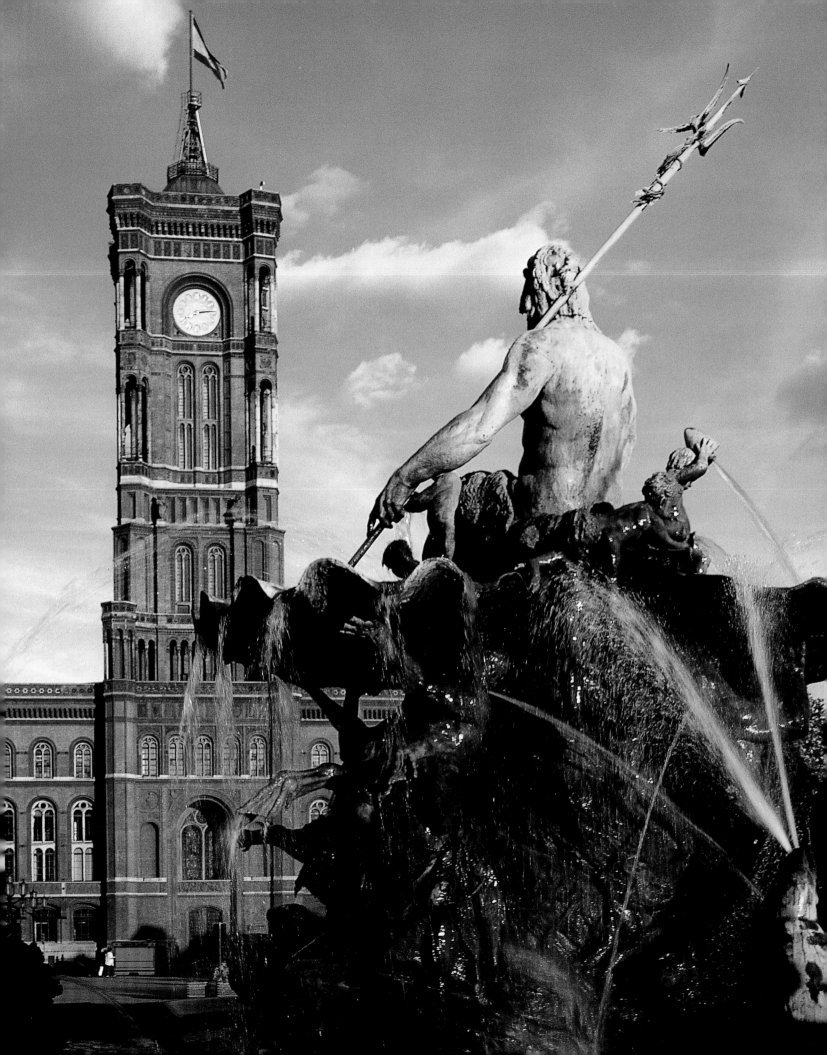

Page 58/59:
The Bode Museum on Museum Island juts out into the river like the bow of a ship. It is named after Wilhelm von Bode (1845 – 1929), the chief director of Berlin's museums who played a major role in building up the city's impressive collection of exhibits.

Left:

This is where the mayor of Berlin gets down to business. The Red Town Hall is called so because of the colour of the bricks – not, as you might think, because of its socialist past. In front of it splashes Reinhold Begas's Neptune Fountain, originally placed between the royal stables and the old Residential Palace.

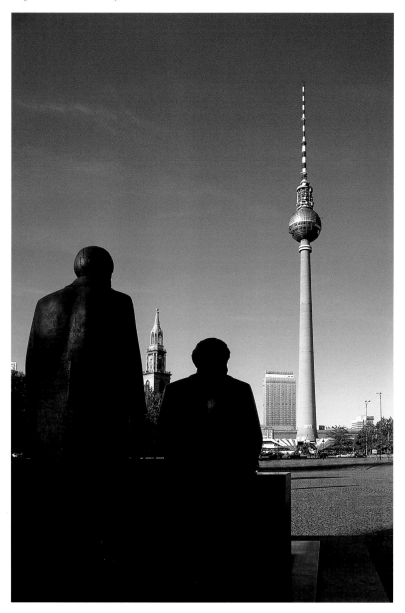

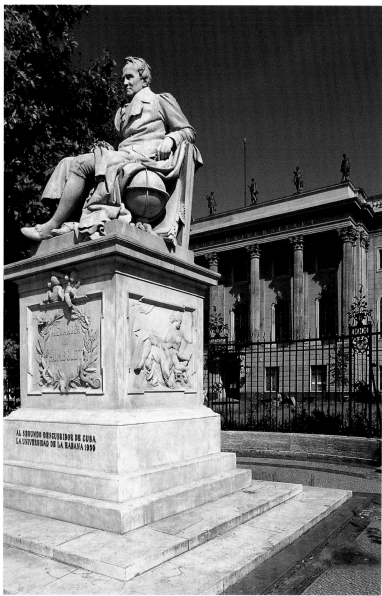

Above:

Ghosts of Berlin past. With the telecommunications beanpole before them, Marx and Engels puzzle over the dialectics of the city's history.

Above:

The hewn likeness of natural scientist Alexander von Humboldt can be found, as one would expect, outside Berlin's Humboldt University. A few yards further on his brother Wilhelm (not visible here) scrutinizes the goings-on in the arts faculty.

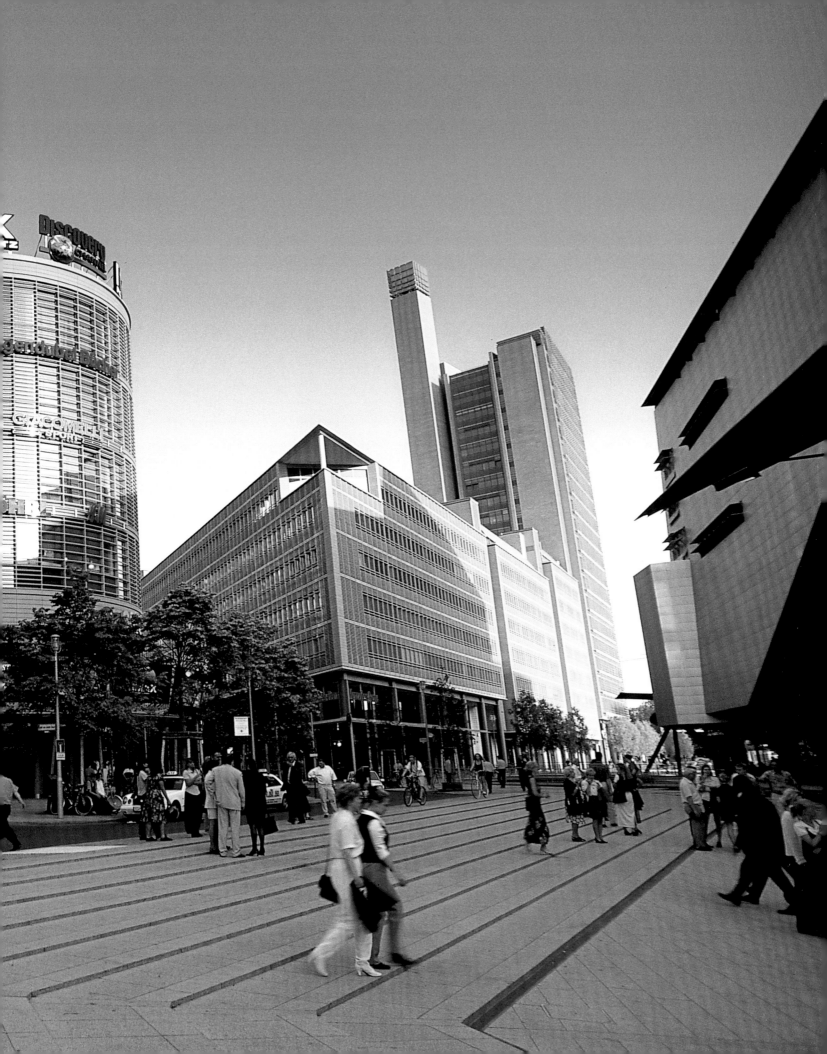

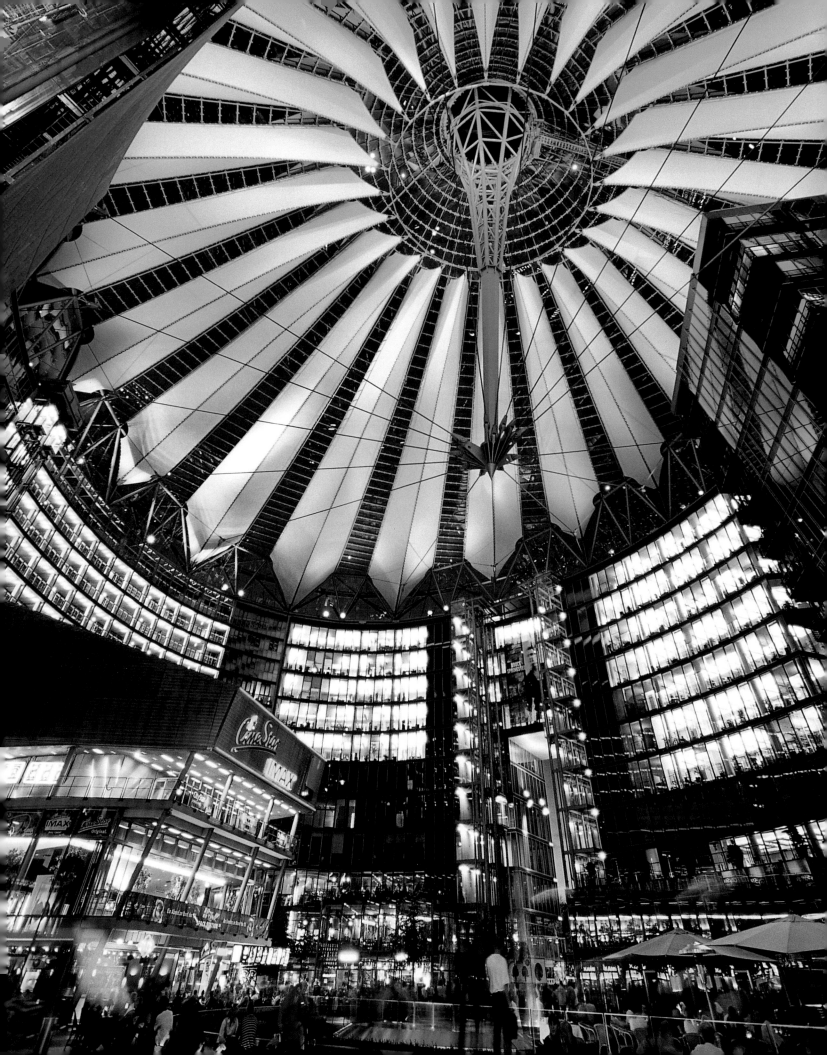

Page 62/63:
The flat steps on Marlene–Dietrich–Platz, part of the new Potsdamer Platz complex, are potentially dangerous if you do not watch where you are going. The bulbous tower behind them houses the Imax cinema with its 3-D screenings.

Page 64:
The glass tent roof stretched out over the piazza of Helmut Jahn's Sony Center looks like a giant umbrella.

Left:
The glass wedge of the Daimler building designed by Renzo Piano and Christoph Kohlbecker cuts into Potsdamer Platz like a huge knife.

Left:
New life has been
breathed into the streets
of Potsdamer Platz. The
brightly lit shopping
arcade squatting beneath
Kollhoff's red tower cer-
tainly pulls the crowds,

*with outlets ranging
from exclusive designer
jewellery to restaurants
to the cheap and cheerful
ALDI supermarket in the
basement.*

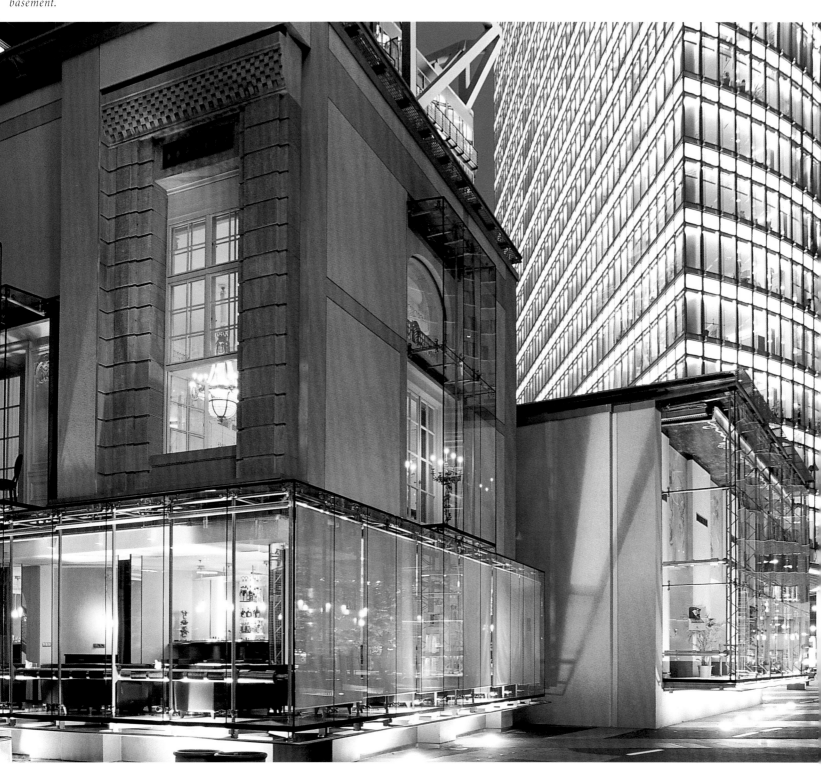

Above:

*Blast from the past. The
Kaisersaal from the old
luxury Esplanade Hotel,*
*the perfect venue for
top-notch receptions and
exclusive gatherings, has*
*been integrated into the
spanking new Sony
Center. Another section*
*of the Esplanade now
accommodates the
resurrected Café Josty.*

Right:
The artificial rainwater lakes on Potsdamer Platz serve an ecological purpose. It is hoped that they will have a positive influence on the tower block microclimate.

Below:
The hunchback of Notre–Dame can currently be found limping across the stage of the Musical Theatre on Marlene–Dietrich–Platz.

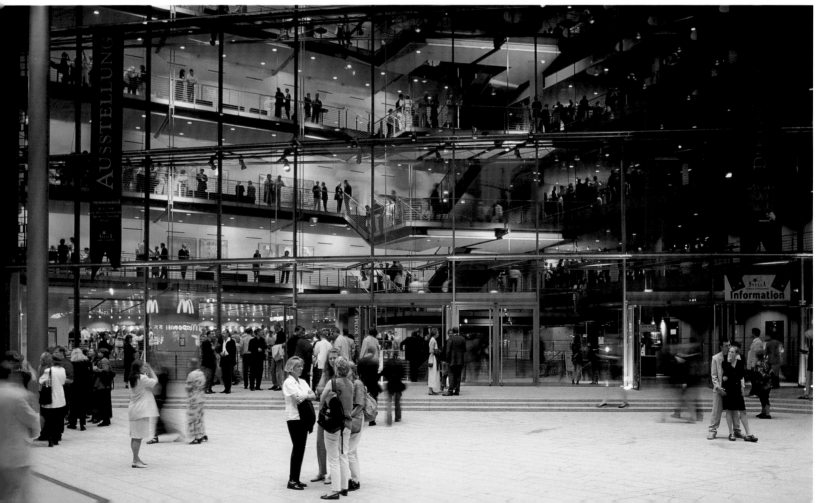

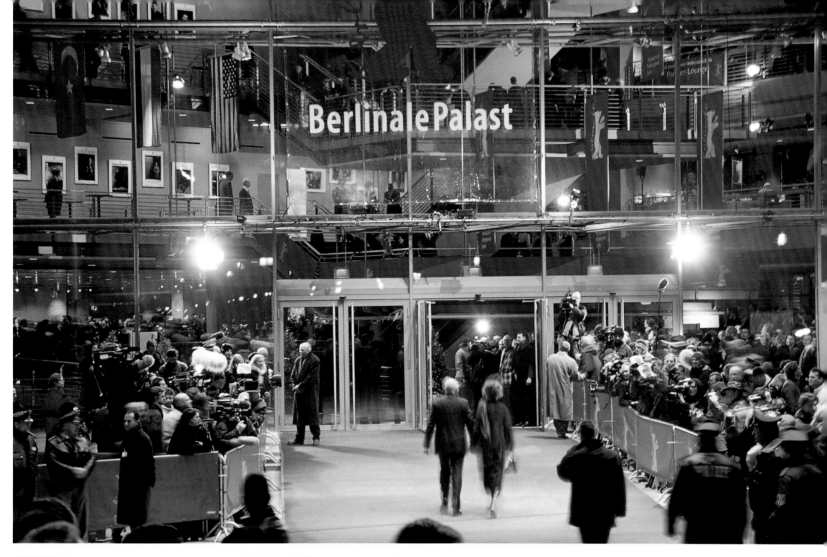

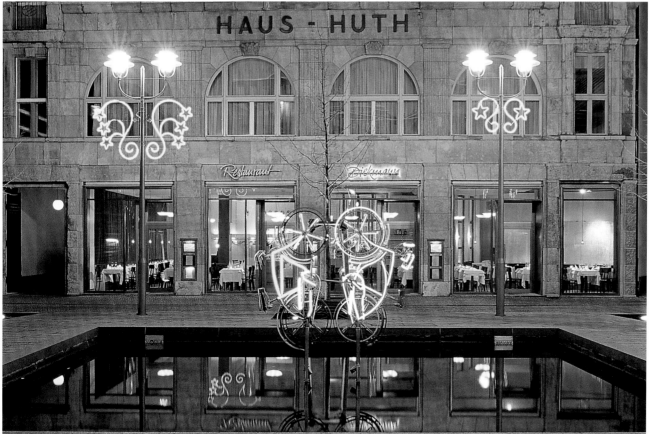

Above:
During the International Berlinale Film Festival the Musical Theatre turns into Little Hollywood, with nervous movie directors, producers and actors waiting to see if they are up for a Golden or Silver Bear this time around. With Cannes and Venice, the Berlinale is one of the highlights of the film year.

Left:
Weinhaus Huth is the only original remnant of the old Potsdamer Platz. Neon bikes by Robert Rauschenberg irradiate the fountain in front of the tavern.

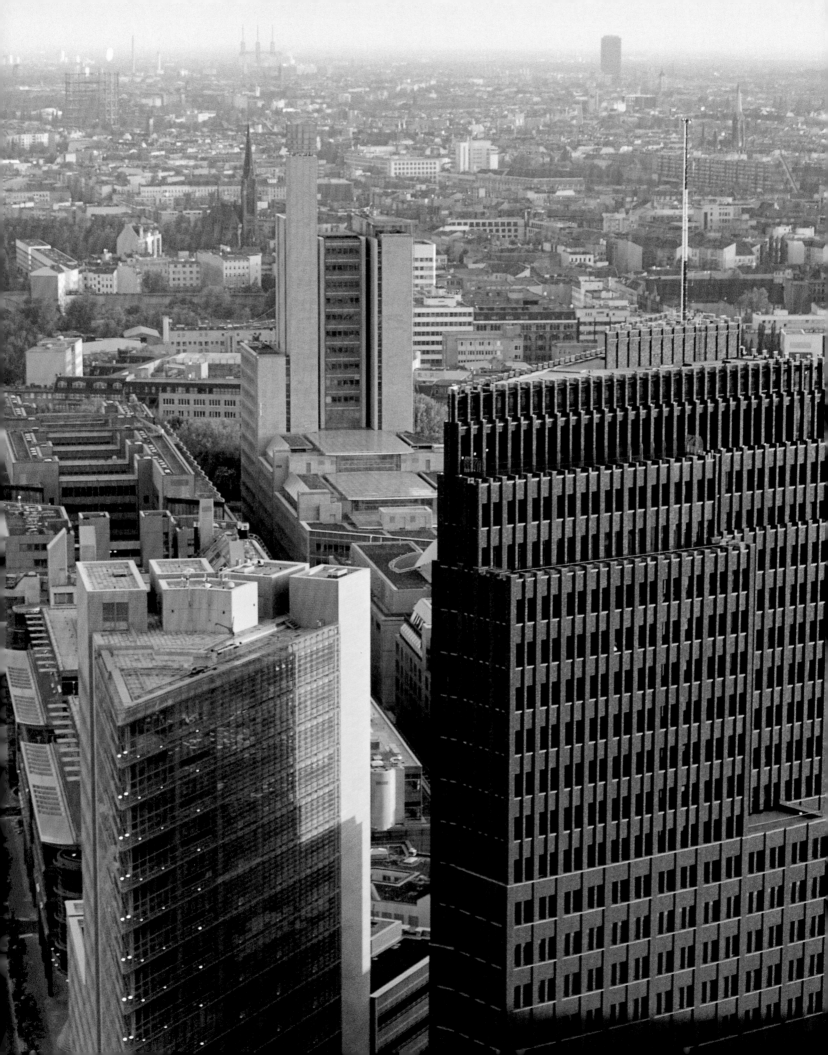

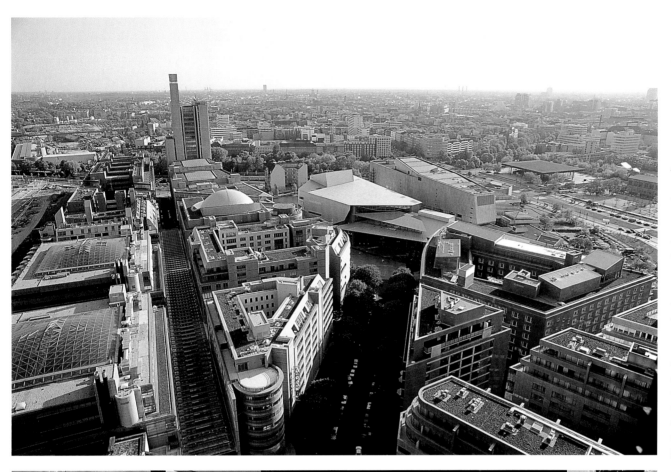

Left Page:
Despite all the hype, the skyscrapers on Potsdamer Platz are not all that typical of Berlin. You can be whisked up the Kollhoff building – erected in cautious reference to Art Deco forebears in New York – in the fastest lift in Europe. The arbour on the 24th and 25th floors is open to the public and has fantastic views out over the city.

Left:
Looking south from the top of the Kollhoff building, you can see the new shopping arcade on the left and the Debis offices in the background. Hans Scharoun's golden state library and Culture Forum (back right) seem Lilliputian in comparison.

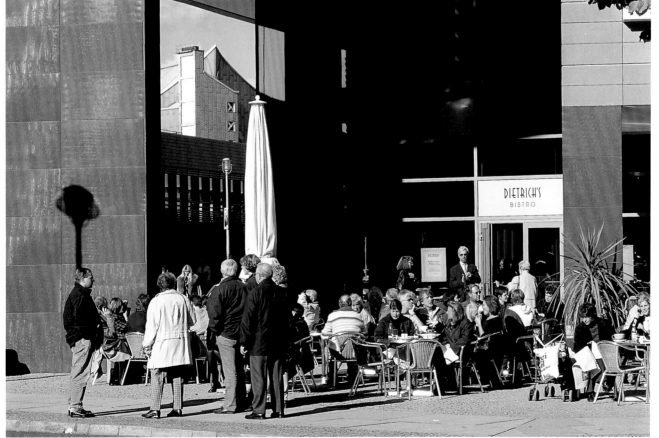

Left:
Dietrich's on Marlene–Dietrich–Platz is a bistro and pavement café during the day and a cocktail bar at night.

Page 72/73:
The maxim of the mega-musical Love Parade seems to be »the more the merrier«. Party-goers bop up the Straße des 17. Juni to the Victory Column in the background for the final fling.

71

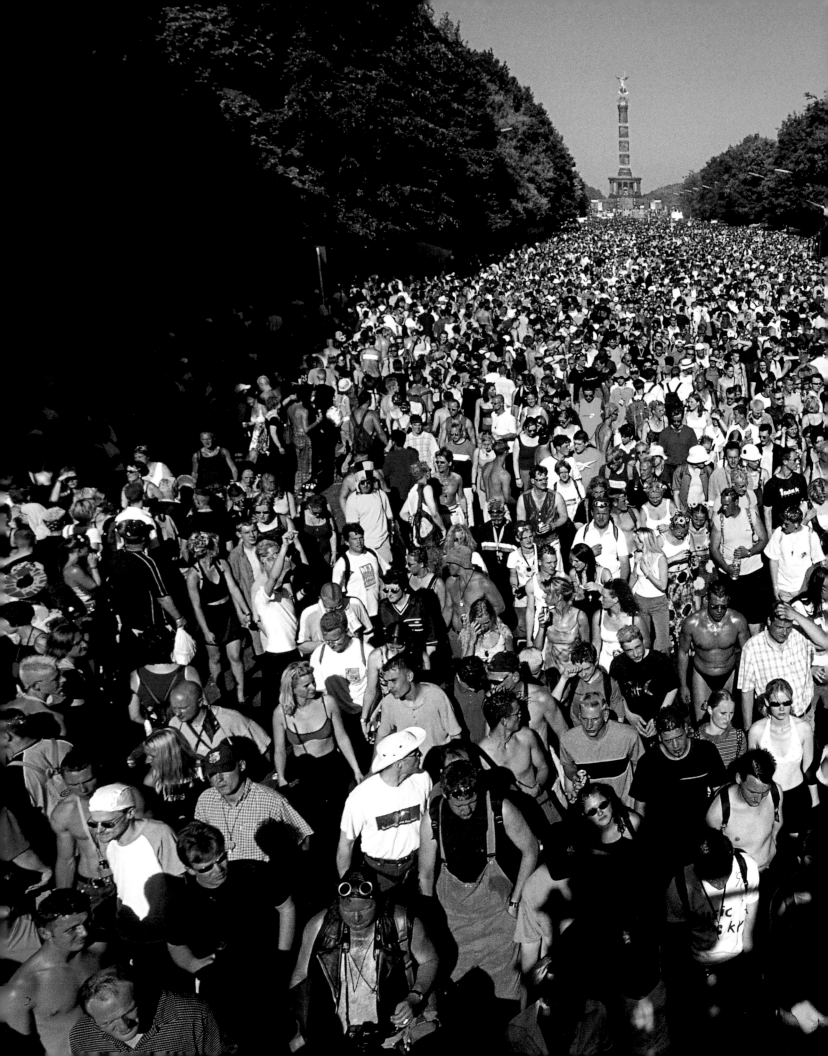

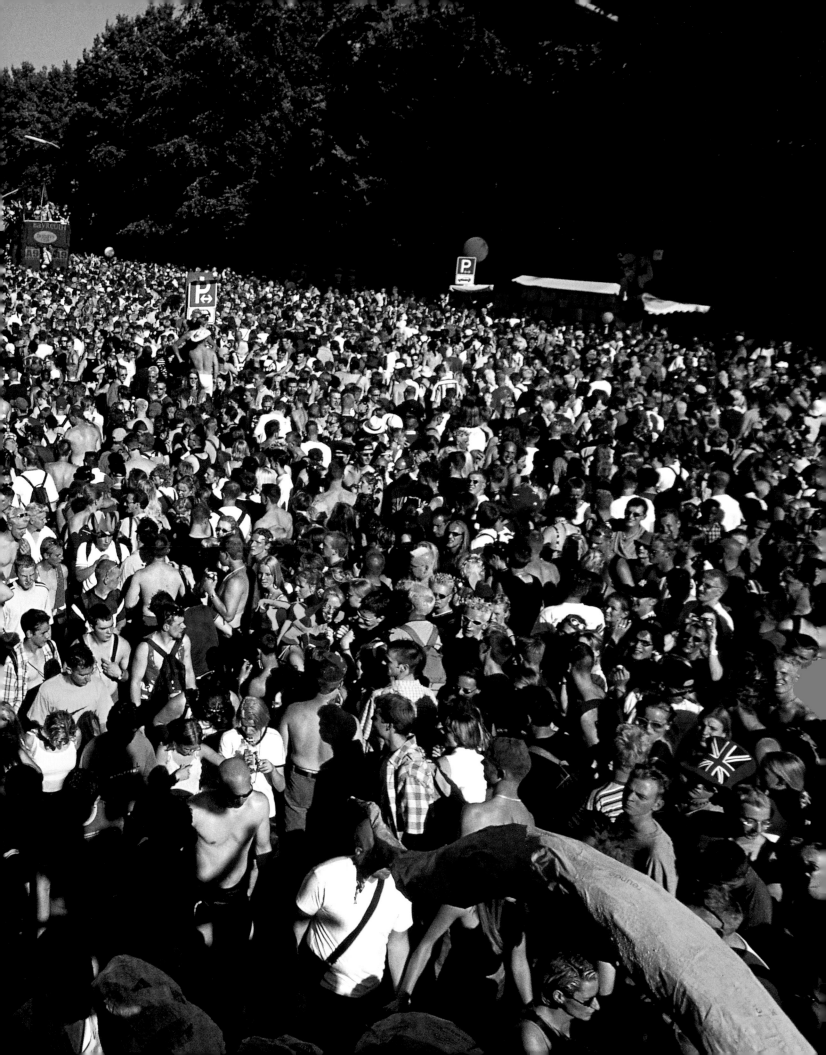

THE LOVE PARADE

The fun factor is measured in BPM; the greater the number of beats per minute pounding eardrums, the hipper the Love Parade. It all started at the end of the 1980s as a relatively modest affair on Kurfürstendamm. Over the years more and more Techno disciples followed the call of DJ Dr Motte, the number soon spiralling out of all proportion. The crowds flocking to the Parade each July are now so immense that the fun-loving event has long outgrown the boulevard running from Charlottenburg to Wilmersdorf. Each year two million legs shake, rattle and roll along the east-west axis in Tiergarten, gyrating to 40,000-watt speakers lashed up to 50 articulated lorries, each trying to outboom the other. Atop the lorries animators dance their hearts out to get the punters going, bopping from Ernst-Reuter-Platz to the Brandenburg Gate and then back to Victory Column.

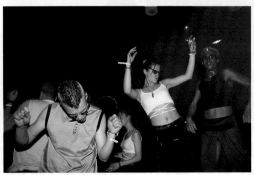

LOVE, PEACE AND BROTHERHOOD

Eccentric gear, garish makeup, wacky haircuts, shrill accessories and a fair amount of bare skin are absolutely vital if you are to stand out in the already zany crowd. As the day draws to a close it is big party time around Victory Column and then off to Berlin's clubs going flat out all night. The jolly jamboree rocks on until noon the next day, the party-goers bathed in sweat and, in some cases, close to collapse. The mood among ravers, whistles blowing and bellybuttons showing, swings from kids' birthday bun-fight to pep-pill beano to carnival à la Rio.

When the masses descend by car, coach, plane or on one of the over 100 trains specially put on for the event, a state of tourist emergency is declared in Berlin. Hotels, B&Bs and any spare inches of floor with friends and relatives are full to the brim. Tents are erected willy-nilly or sleeping bags simply rolled out under the open sky. More than 2,000 police and 800 first-aid attendants wait in the wings, standing by to make sure that the motto of love, peace and brotherhood is allowed to prevail.

Nature conservationists are none too happy about the neo-hippie situation, however, as after the revellers have gone Tiergarten is left suffocating under mountains of rubbish and the ground, saturated with urine and trampled into mud by millions of pairs of feet, barely recovers in time for the next onslaught. Despite this the people of Berlin themselves are all for it; if there was not such a thing as the Love Parade already, someone would have to invent it – pronto! Many other cities have copied trendsetter Berlin and now stage their own Parades, Tel Aviv and Leeds among them.

While on that night to end all nights mums and dads worry that their offspring could succumb to the wicked delights of Ecstasy or – possibly even worse – come home pregnant, marketing strategists rejoice. With its many highlights, the rave is an economic entity of the first order. Cash tills have never rung so cheerfully. Promoters are laughing all the way to the bank. Even Gotthilf Fischer, he of the choirs, has jumped on the bandwagon and now merrily conducts choruses of teeming bodies. At the end of the 2000 Love Parade the 72-year-old thought the spectacle as peaceful as a town fête yet »tremendous« and promised to join in next time around. When emotions are running high, Techno is the music of the masses. Anything goes and you can do whatever you want – as long as you enjoy yourself, of course.

Top left:
Each July the masses descend on Berlin for the biggest and best party of them all: the Love Parade.

Bottom left:
Whether inside or out, still the beat goes on, here in the Kesselhaus at the Kulturbrauerei.

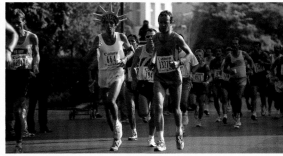

THE MERRIER THE BETTER

The maxim of New Year's Eve at the Brandenburg Gate is similar: the merrier the better. The outdoor booze-up around the symbol of Reunification has been a tradition since New Year 1989/1990 when East and West were locked in a drunken embrace, champagne bottles akimbo. A million people were estimated to have hit the streets that night. The shows now staged and the fireworks let off from Großer Stern to cast out the old, bring in the new, pull similar crowds, even if now the commercially flogged happening is not nearly as spontaneous as in the year when Germany reunited.

The Straße des 17. Juni running from Victory Column to the Brandenburg Gate and spilling over into Unter den Linden is also a major party tract during the Berlin Marathon, in which more people take part every year. The same street is the venue for Blade Night with its thousands of fans, when squealing tyres make way for the whoosh of rollerblades.

Perhaps the craziest of Berlin's megaevents are the smaller and more exclusive culture carnivals in Kreuzberg, where Ethnopop-lovers freak out to their fave tunes, and Christopher Street Day (CSD) in June, inspired by our American cousins. Almost 500,000 homosexuals and lesbians whirl their amazing floats from Kurfürstendamm to Victory Column, the (phallic) symbol of Gay Berlin. The costume designers at the Friedrichstadtpalast could learn a thing or two from the mad attire of CSD's drag queens, which is truly gay in all senses of the word...

Above:
The Love Parade is a celebration of itself. What started out as a get-together of 500 in 1990 has become a giant cultural movement with two million disciples.

Top right:
Stamina is also required if you are to join the other thousands of runners on the track of the Berlin Marathon.

Bottom right:
Berlin has something for everyone; June is the month of Christopher Street Day.

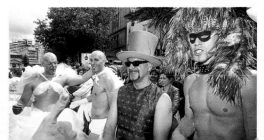

Below:
Tiergarten, once the elector's game reserve west of the royal capital, was turned into a public park in c. 1835 by Peter Joseph Lenné. The city's chief oasis was complete- ly destroyed during the Second World War and in its aftermath, when freezing Berliners chop- ped down the trees for fuel. In 1949 the reland- scaping of the park began.

Right:
The Landwehrkanal, a waterway popular with pleasure steamers and rowing boats alike, runs right through the centre of the park.

Right:
The lush greenery of the Englischer Garten is part of Tiergarten and borders on the park surrounding Schloss Bellevue, the official seat of the Federal President of Germany.

Below:
Plays, films, literature and Ethnopop from all corners of the globe are presented in and around the Congress Hall in Tiergarten. Built in 1957, the »Pregnant Oyster« is more formally known as the House of World Culture.

Above:
You need several days to fully investigate the impressive menagerie resident at the zoo in the southwest corner of Tiergarten.

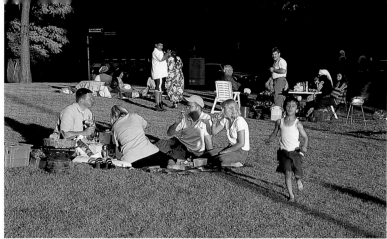

Left:
During the summer months Tiergarten buzzes with the sounds and smells of locals and tourists picnicking and barbecuing.

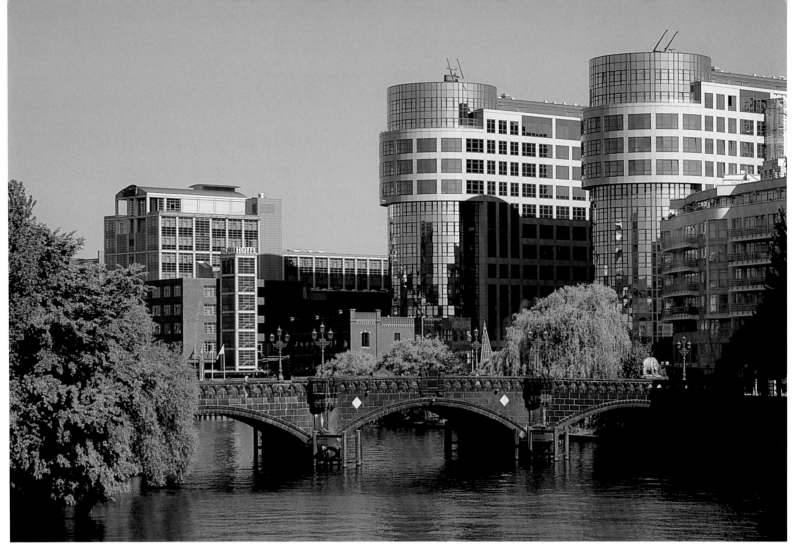

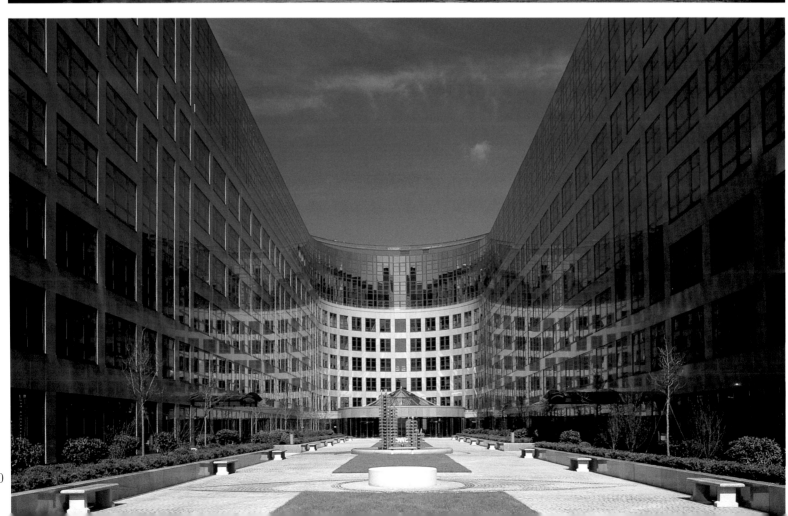

Top and bottom left: *The bend in the Spree at Moabit. The offices built by pizza king Ernst Freiberger have been rented out to Germany's home secretary and his* *administration, allowing ministerial staff to gaze out of their windows onto neat, quadratic courtyards or envy the general public relaxing on the banks of the river.*

Above left and right: *Architecture ancient and modern. On the outskirts of Tiergarten, the long–established diplomatic quarter, the cutting edge of the new Scandinavian* *Embassy slices through the air. On the right an elaborate façade on Thomasiusstraße in Tiergarten bears witness to Berlin's glorious past.*

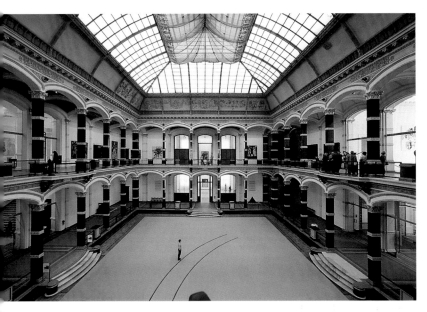

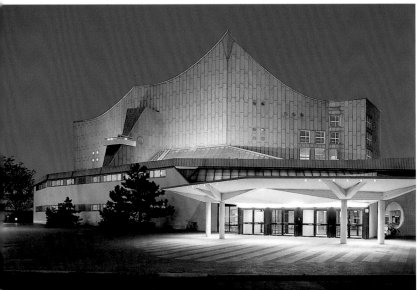

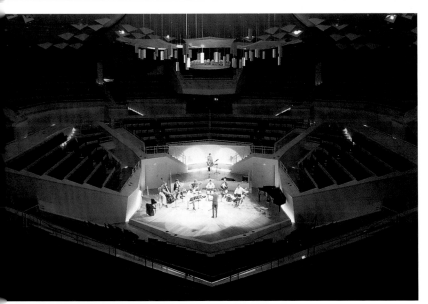

Top left:
The war-torn Martin Gropius Building, restored in the 1980s, is now managed by the state ministry of the arts. The building is ideal for staging large–scale exhibitions.

Centre and bottom left:
The world-famous Berlin Philharmonic Orchestra plays at home at the

Philharmonic Hall, with the Chamber Music Hall beside it (bottom, also designed by Hans Scha-

roun). In 2002 resident conductor Claudio Abbado will hand his baton over to Sir Simon Rattle.

Below:
The New National Gallery at the Culture Forum, completed in 1968, was built from plans Ludwig Mies van

der Rohe had originally drawn up for the headquarters of Bacardi Rum, then still under Cuban ownership. To the left of

it is a steel sculpture by Alexander Calder, with St Matthew's Church aspiring to the heavens on the horizon.

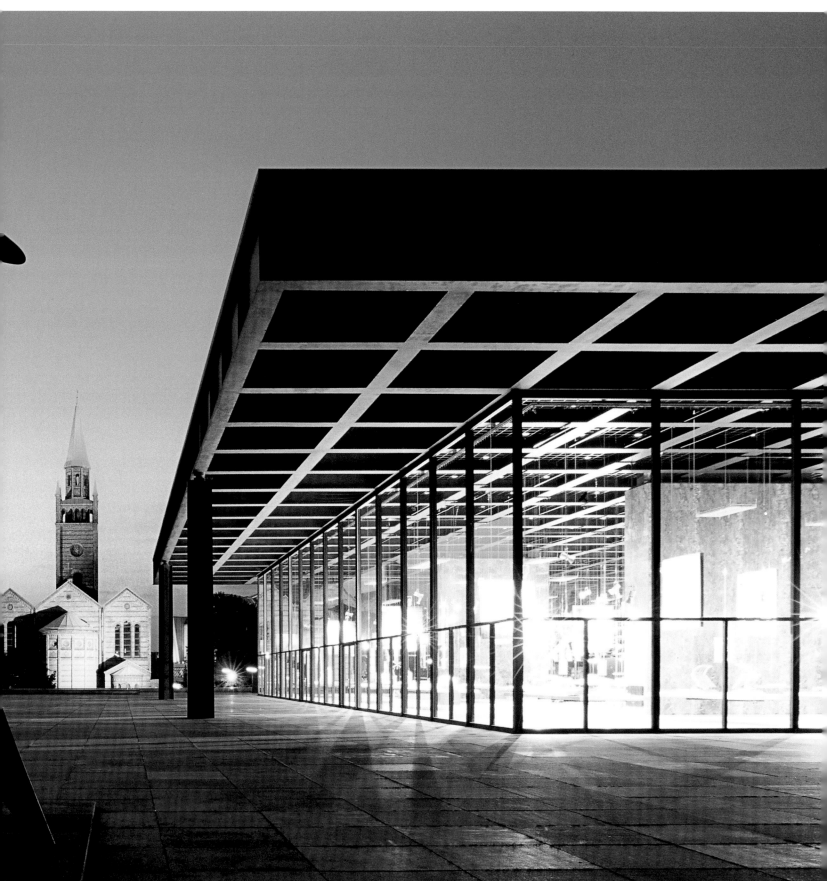

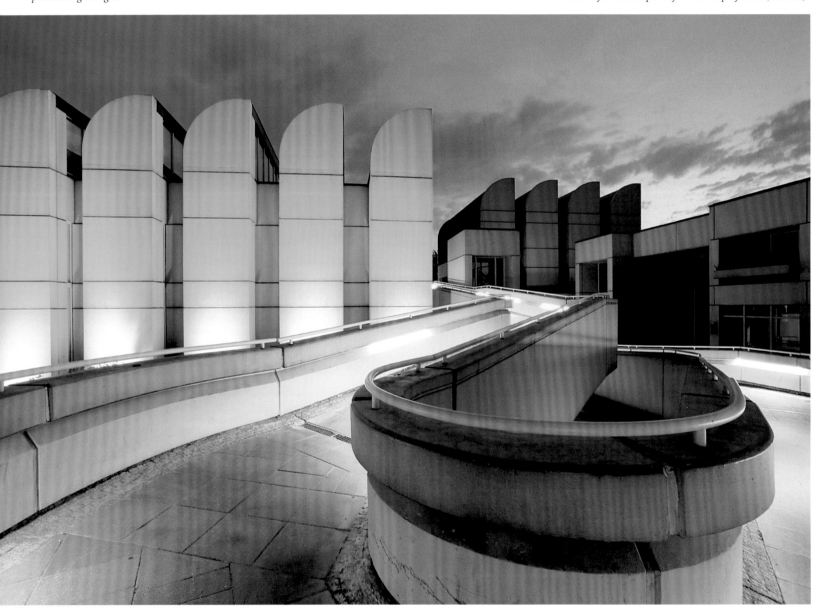

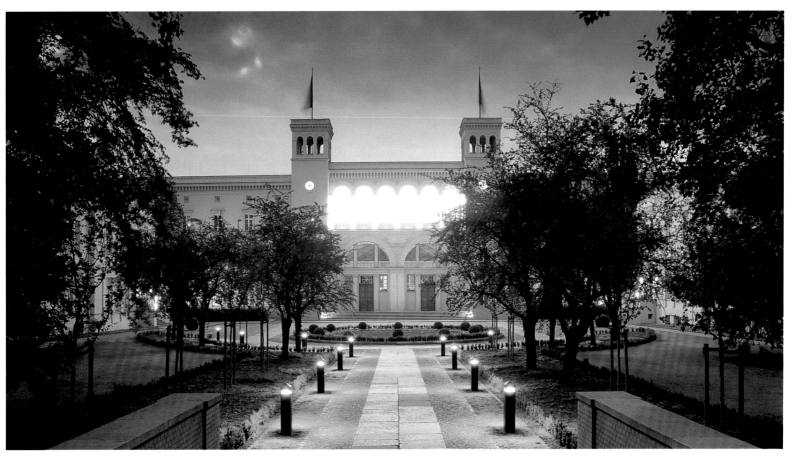

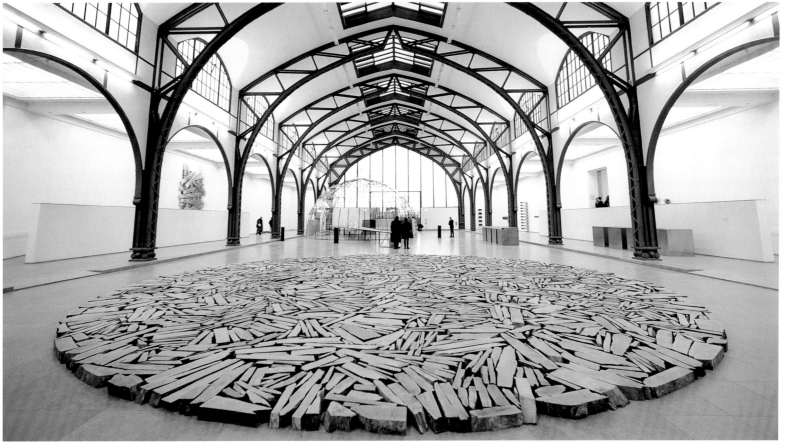

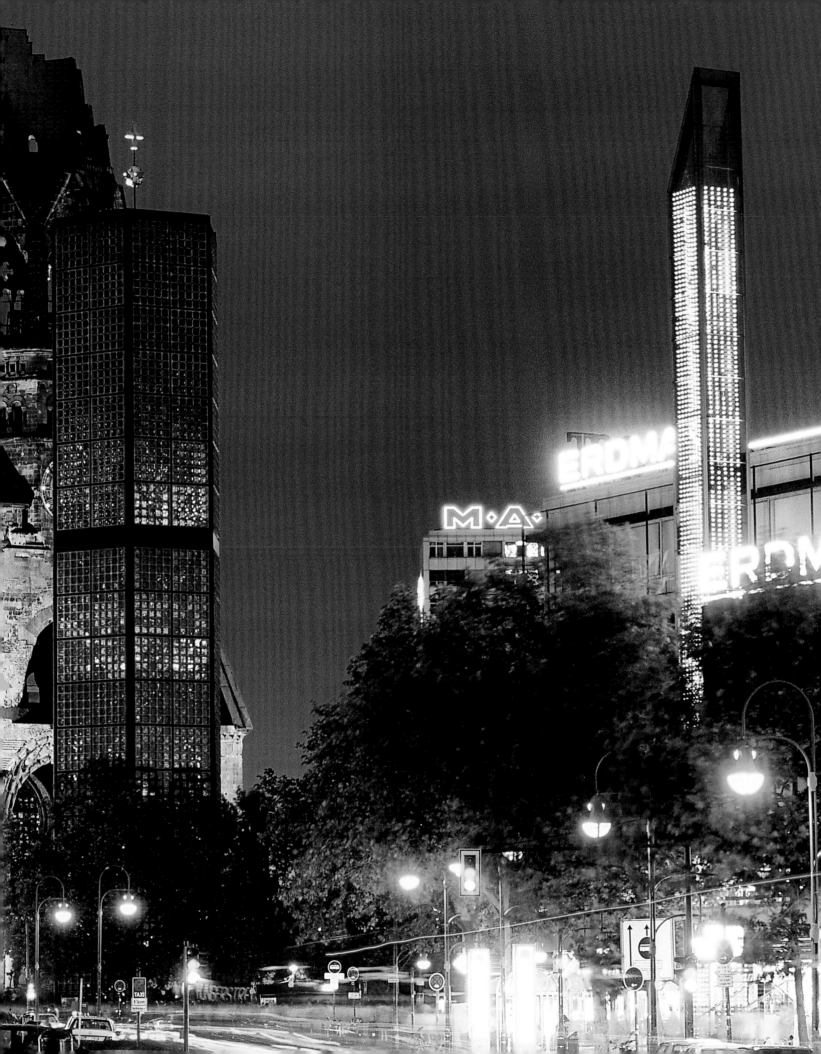

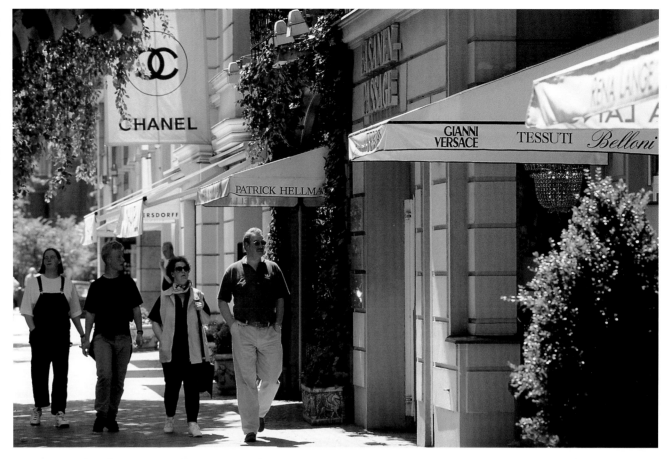

Shopping for the hard to please. The boutiques on Fasanenstraße, which crosses Kurfürstendamm, are especially exclusive, with potential purchases ranging from expensive jewellery to fashion accessories, art and antiques to a good book in the Literaturhaus basement.

Schrill department store and Café Bleibtreu on Bleibtreustraße stand in crass contrast to stylish Fasanenstraße.

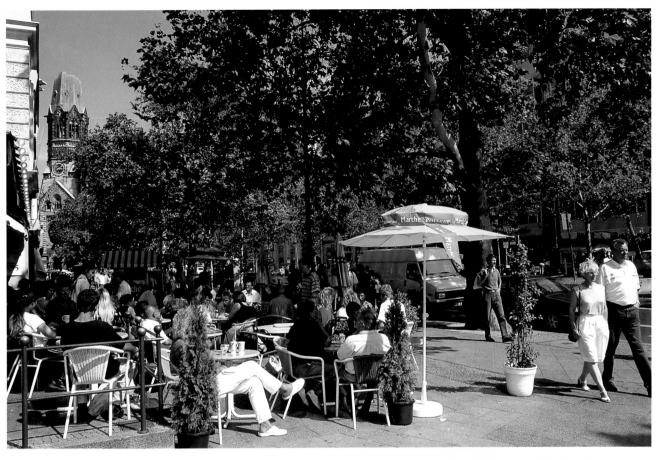

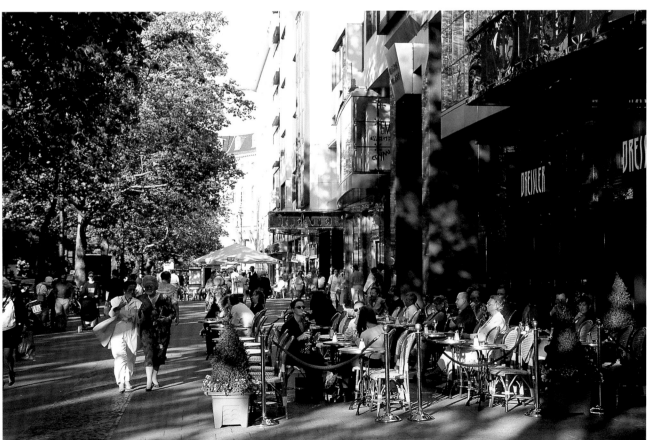

Top and bottom left:
The traditional Möhring cafés on Kurfürstendamm have all disappeared and even Kranzler on the corner of Joachimstaler Straße is a mere shadow of its former self. Yet there are still plenty of places to go for »Kaffee und Kuchen«. The first rays of warm sunshine entice people out onto the pavements at the coffee houses Marché (top) and Dressler (bottom).

89

Below:
For decades Berlin's artists and intellectuals and the Bohemian world in general have wandered into Paris Bar on Kant-straße. Actor Otto Sander, for example, has become part of the furniture, a bronze plaque firmly affixed to his favourite chair.

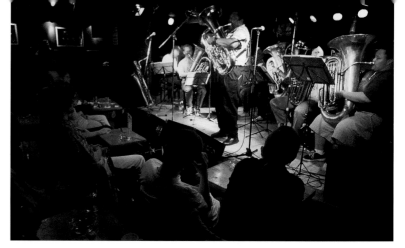

Right:
Like Paris Bar, the Quasimodo jazz club in the vaults of Delphi Cinema is also on Kantstraße.

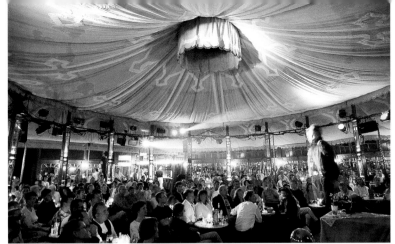

Left:
Cabaret, curiosities, all kinds of clobber and a constant clientele are guaranteed at Bar jeder Vernunft on Schaperstraße.

Below:
Things are much quieter at devotional stockists Ave Maria in Schöneberg.

Above:
At the Kramberg boutique on Kurfürstendamm you can don smart apparel in a classy environment.

Everything revolves around money here. The elongated ribbed roof of the Ludwig–Erhard–Haus in Charlottenburg has earned it the unlikely nickname of proboscidian. In it are the chamber of commerce and the Berlin stock exchange. The futurist interior is a fashionable backdrop for makers of promotional films.

Good taste can be expensive. If you wish to indulge, go to the time–honoured Kaufhaus des Westens (KaDeWe) near Wittenbergplatz.

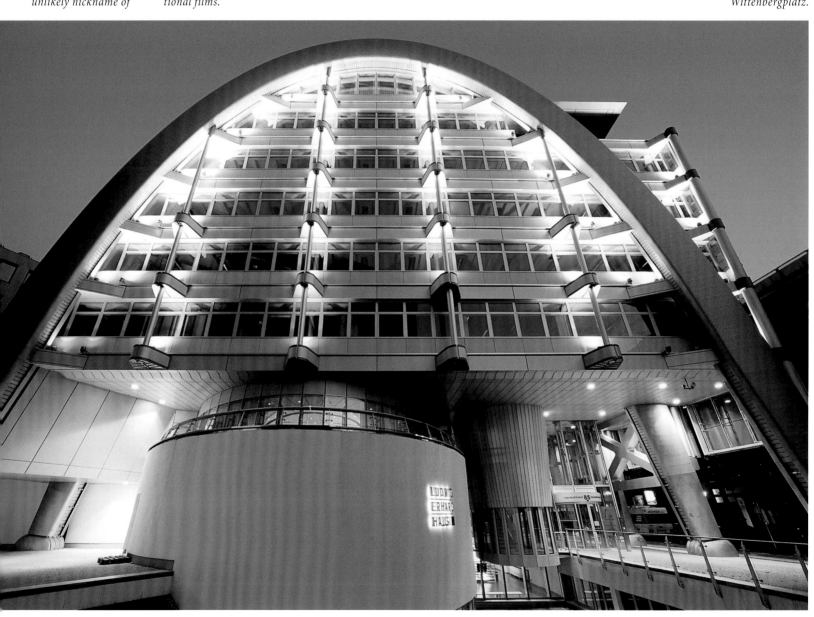

Helmut Jahn's new Kranzlereck between Kurfürstendamm and Kantstraße has yet to establish itself as a major shopping venue.

Do the giant aviaries hidden in the interior perhaps suggest that at present any business undertakings are a touch high-flown?!

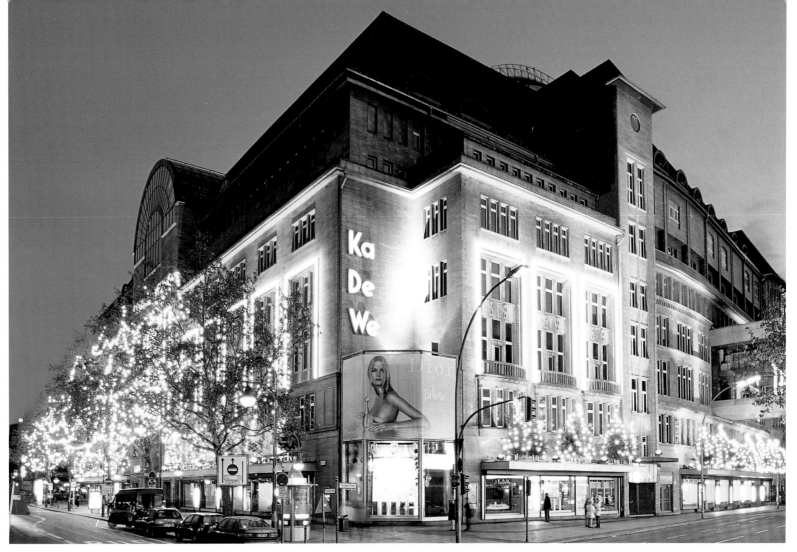

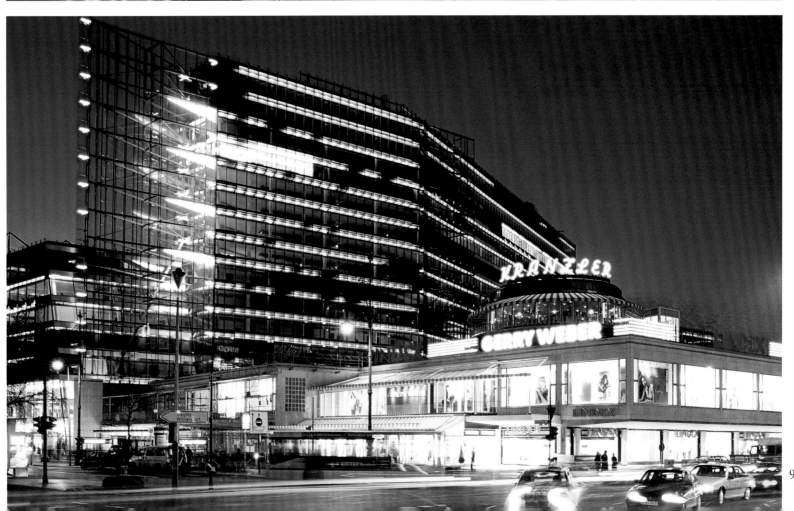

93

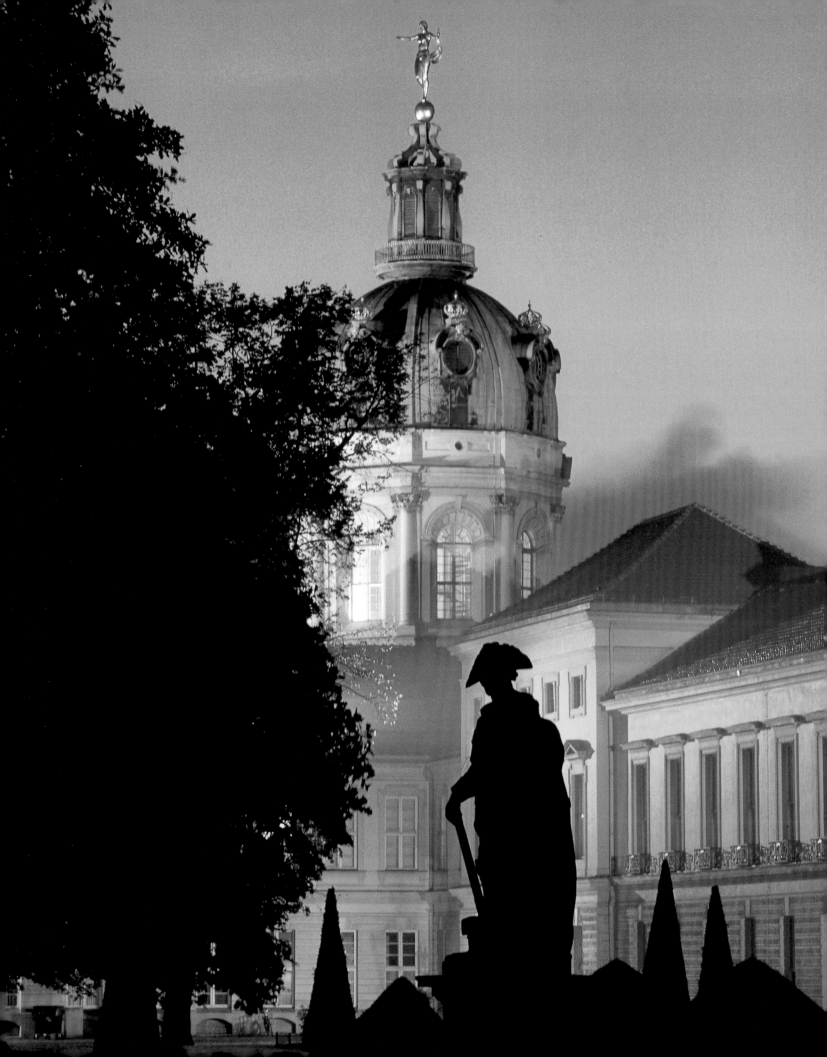

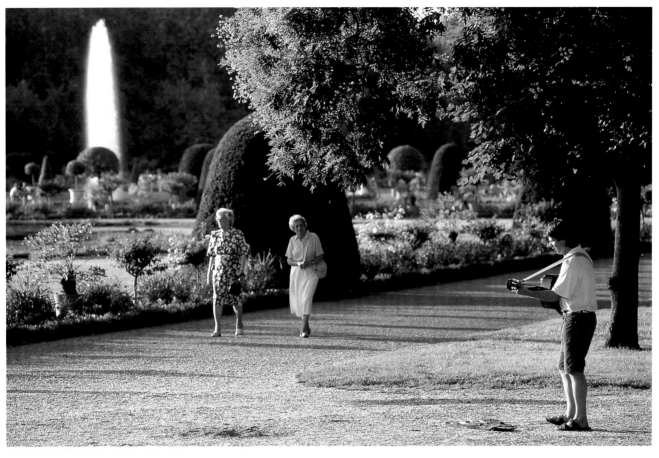

Left page:
Old Fritz on watch
outside the wing of
Schloss Charlottenburg
added by Knobelsdorff.
The architect was
commissioned to extend
the palace by Frederick
the Great, Sophie
Charlotte's grandson.

Left:
The royal abode is
surrounded by formal
Baroque gardens and
an English park where
you can promenade
under shady trees along
winding paths.

Left:
In the park to the east
of the palace stands the
pavilion designed by
Karl Friedrich Schinkel
as a summer residence
for Frederick William III
and Countess Liegnitz.

LOCAL CULTURE

Like a gate to other worlds: entertainment machines like the »Sage Club« carry dance-lovers on ever-new imaginative journeys with never-ending creativity. Here, elves, goblins and forest dwellers rule the night in the fun factory.

In today, out tomorrow: fads and fashions seem to change faster than ever. For the fans of Dutschke, Marx and Coca-Cola Wilmersdorf and Charlottenburg, and Savigny-Platz and Ludwig-Kirch-Straße in particular, used to be »the« place to live, not least due to the low rents. Most of the 1960s hippies are now part of the establishment yet many of them have remained loyal to their old stamping ground. They sometimes still frequent their old haunt, the Zwiebelfisch pub, even if only for purely nostalgic reasons. The young have long since disappeared, first to Kreuzberg, then to Prenzlauer Berg, whose crumbling façades seemed to exert a strange magnetism on the Bohemian opposition to the GDR, and now to Friedrichshain and the pubs and clubs lining the Simon-Dach-Straße. In a few years students and protagonists of the offbeat might consider it hip and trendy to lodge in the cheap prefabs of Hellersdorf or Marzahn. As in London, New York and Paris, each generation will earmark their own special corner of the city as theirs. Berliners call their local district »Kiez«, the place where they live, shop and feel at home. »Kiez« can be in Neukölln or Wedding, around the extensively restored Hackesche Höfe or at the Ufa factory in Tempelhof with its menagerie of autonomous tenants, green businesses and the arts, an exemplary complex created by the owners of the old film studios. The Kulturbrauerei in Prenzlauer Berg works along similar lines. The old brewery now bubbles over with creative enthusiasm and not beer, reason enough for Günther Grass to pay homage to it in his novel »Ein weites Feld« (A Wide Field). The countless clubs, from Maria am Ostbahnhof to the legendary techno dive Tresor (in the ramshackle strongroom of the old Wertheim department store on Leipziger Platz) to the Sage-Club, offer a mixture of disco, live music, go-go dancing and an exuberant and slightly freaked-out joie de vivre. Saturday Night Fever? Definitely old hat.

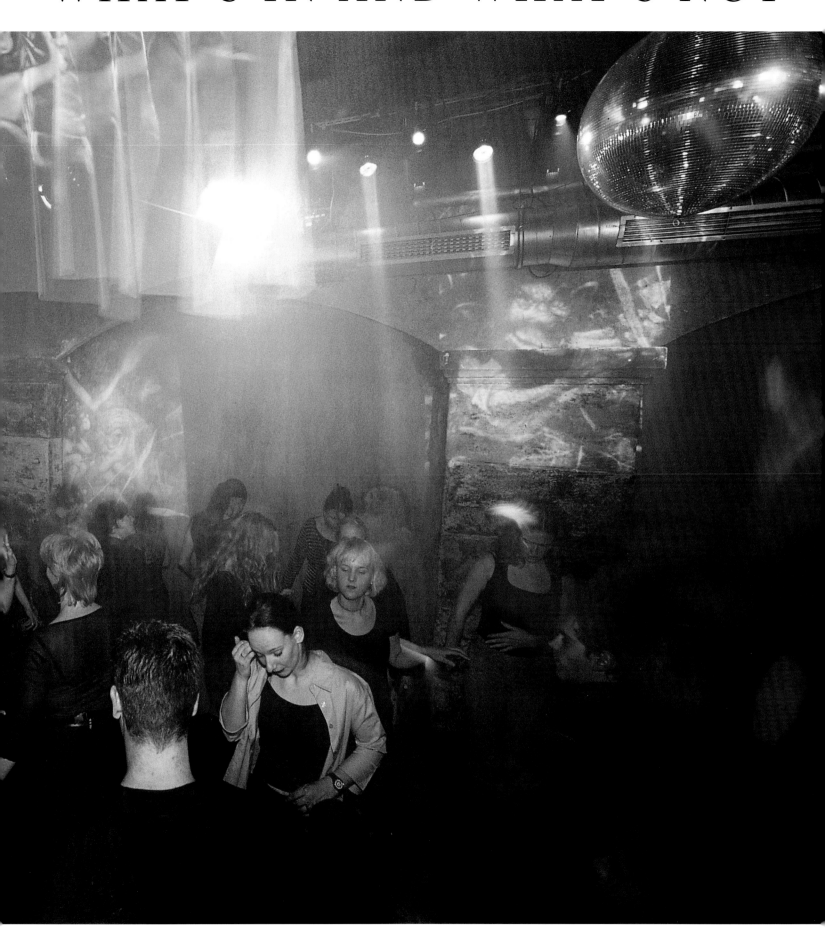

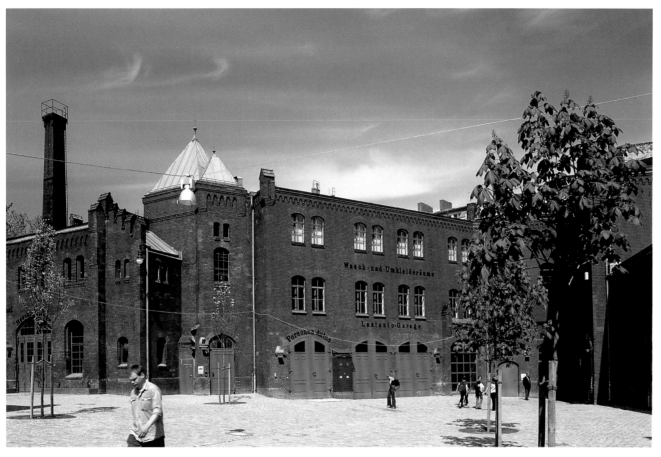

Left page:
Long before the Wall came down the Gethsemanekirche in Prenzlauer Berg was where opposition to the GDR regime was nurtured, fired by the Christian peace movement calling for a move »from swords to ploughshares«.

Top and bottom left:
The Kulturbrauerei on Knaackstraße in Prenzlauer Berg provides food, drink and entertainment, with music, theatre, art and literary readings staged in a much more relaxed environment than that of some of the more exalted cultural venues.

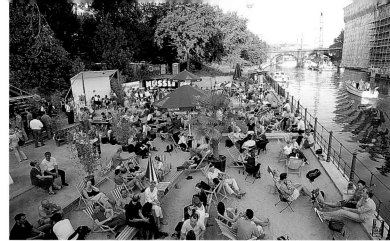

Right:
Thousands of cubic metres of fine sand make it possible to enjoy the sunshine in the middle of the big city just as much as at the seaside. The »Strandbar« on the Spree River is inviting for sunbathers by day and by night ideal for parties in a relaxed ambience.

Below:
There's always enough time for a little chat, since you'll always meet a familiar face on Oranienburger Strasse.

Centre and far right:
The spring sunshine is good for business at Berlin's street cafés.

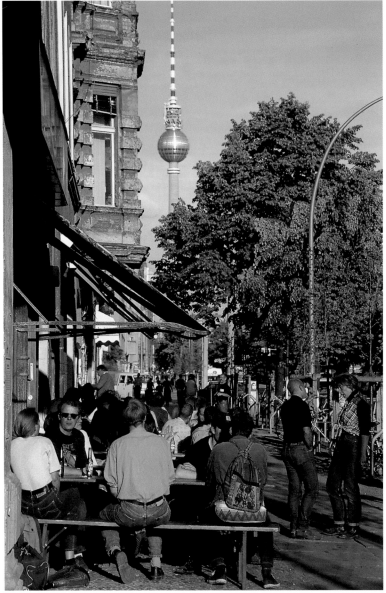

Right:
Kollwitzplatz and the streets leading off it are lined with pubs, bars and outdoor cafés.

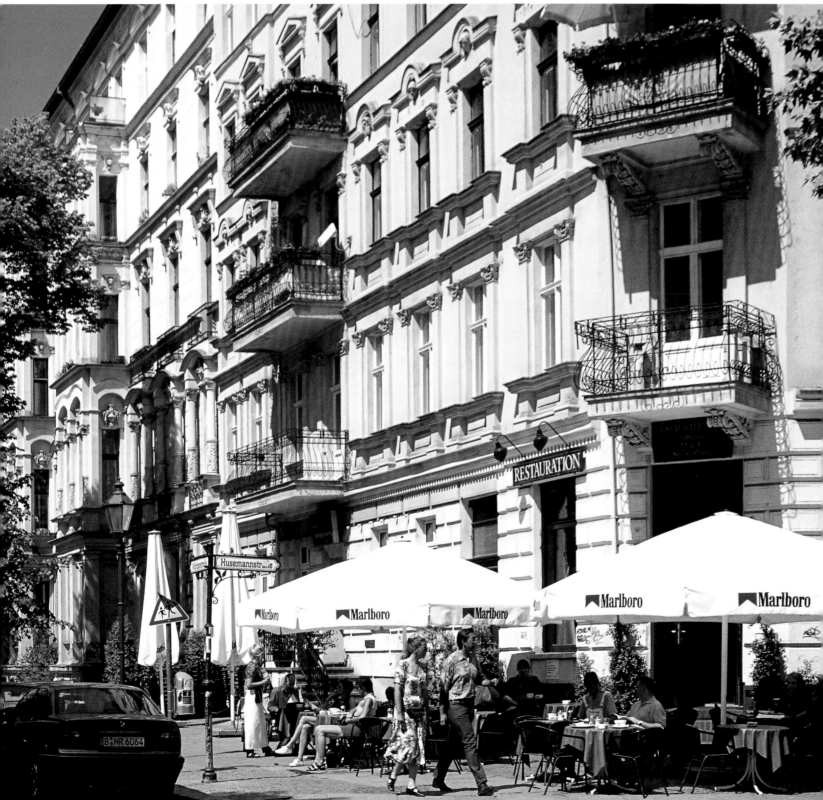

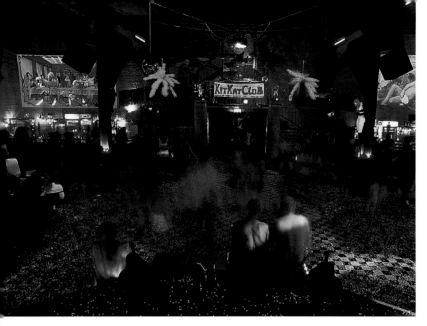

Main photo and far right:
The nights are long at one of Berlin's most popular venues, the Sage–Club on Heinrich–Heine–Straße, with its glittering go–go dancers (below) and blue bar (far right).

Right:
Those born to boogie with a less conservative taste in Techno go to Sternradio on Alexanderplatz.

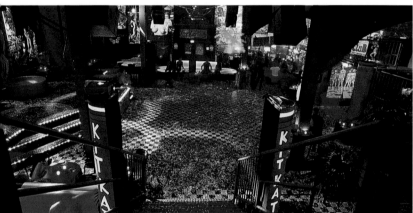

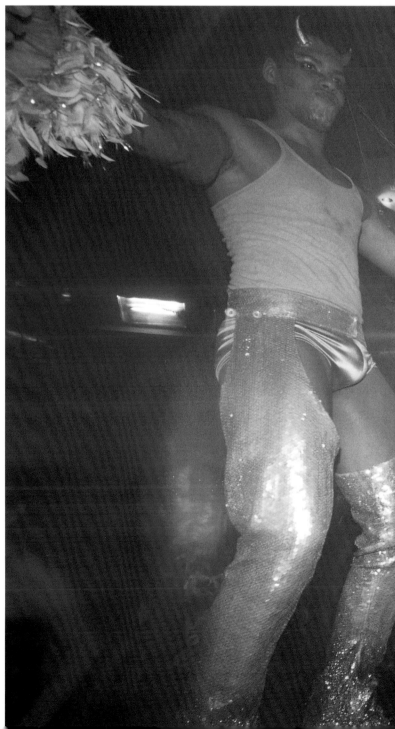

Top and above centre:
The KitKatClub is famous even beyond the borders of Berlin as an inside tip for the hedonistic avant-garde. For years the club has been one of the most popular spots for cosmopolitans not only for its music, but above all for its erotic, exotic permissiveness. Always a must: the dress code.

Above:
The Polar-TV amusement park not only draws dance freaks, but also offers its quarters for events of all kinds.

Below:
Architecture critics travel to Berlin from all over the world to vet the Jewish Museum on Lindenstraße in Kreuzberg, designed by Daniel Libeskind. The contours of the building are intended to emulate a burst Star of David.

Right:
Many intellectual celebrities and business magnates from Berlin's Jewish past lie buried at the legendary Jewish cemetery in Weißensee.

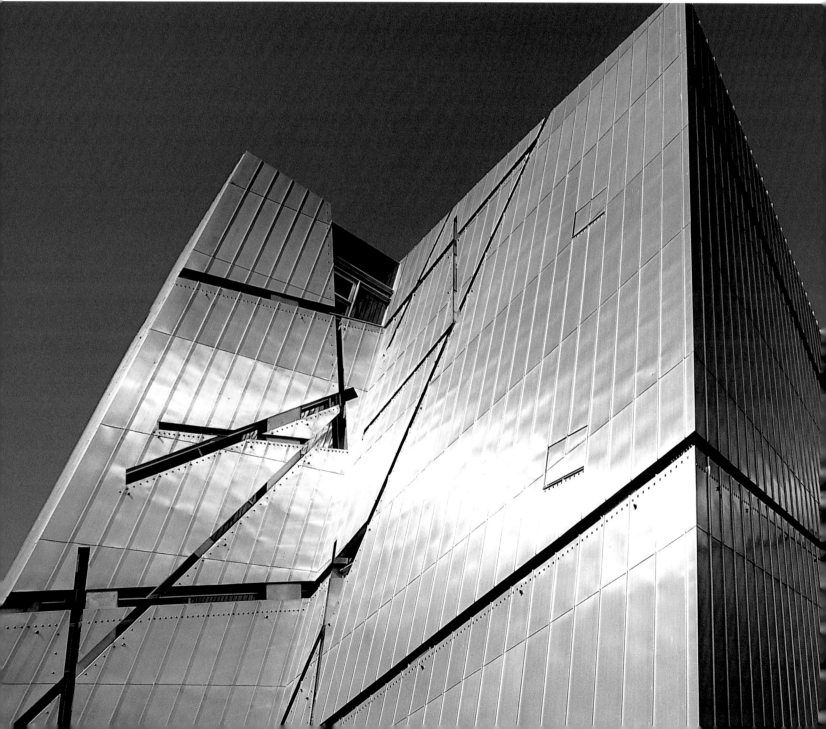

Left:
Evidence of Jewish life in Berlin today near the synagogue on Oranien-burger Straße.

Below:
The bizarre slit windows in the Jewish Museum represent the streets in Berlin where the Jewish community once lived.

First came the »Wall woodpeckers« chipping souvenirs off the »protective wall against Fascism« with a hammer and chisel, then came the now redundant border guards and finished off the job within the space of a few months. They were thorough: today there's hardly anything left of the once 96 miles (155 km) of concrete obstruction which from 1961 to 1989 turned West Berlin into an impenetrable fortress for would-be GDR defectors. Over 100 people lost their lives trying to flee to the West.

Many bemoan the fact that today only a few paltry sections of Wall remain. Attempts to map out the monstrous line of demarcation between NATO and the Warsaw Pact in red brick on tarmac or as red lines painted onto pavements seem pretty pathetic. Writer Heinz Knobloch's call to »beware of green spaces«, with which he was actually referring to memories from pre-war Berlin, can now be applied to any number of dead areas where the border once stood. Some of the best cuts of the old death strip have been snapped up by constructors of luxury buildings, such as Potsdamer Platz and Checkpoint Charlie, where the former border crossing for Allies and non-Germans has been more or less wiped off the face of the earth by the American Business Center. In other places dual carriageways and tram and rail tracks have been reinstated as necessary links between the two halves of town. And the old patrol circuit, now riddled with potholes, is a much-frequented jogging track.

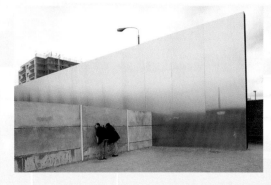

THE BERLIN WALL MEMORIAL

Because so much of the Wall had been eradicated from the city's topography in 1998 a decision was made to install a memorial to it on the corner of Bernauer Straße and Ackerstraße. Consisting of a section 230 feet (70 metres) long and complete with front and rear barricades, floodlights and patrol circuit, the new centre competes with the Museum at Checkpoint Charlie. In the documentation centre opposite photos, recordings and a wooden watch tower remind visitors of the years when Germany was divided. Some of the most spectacular escapes were made here on Bernauer Straße in 1961. While border guards began bricking up windows of houses belonging to East Berlin a few storeys up the last tenants were leaping to freedom while they still could into the outstretched blankets of the West German fire brigade. Pictures like these were broadcast all over the world. One year later, Hasso Herschel's incredible 400-foot (120-metre) escape tunnel found an even bigger echo in the press.

In 1985 the Church of the Day of Atonement which happened to be bang in the middle of the death strip on Bernauer Straße was dynamited. Its bells and deformed steeple cross now stand in front of the new Chapel of Atonement erected in its place. The modern house of worship is a simple oval built from the ancient material clay, surrounded by pale wooden slats. The bricks of the old church were ground and mixed into the clay. When you step inside the chapel designed by Peter Sassenroth and Rudolf Reitermann you come across a glass plate let into the floor. Through it you can see the remains of the old church foundations, cavity blocks from the Wall used to brick up the entrance to the crypt and a dud from the Second World War, resting where it fell.

Berlin's turbulent history is similarly intense at the bit of Wall left on Niederkirchner Straße. On one side are the excavated cellars of

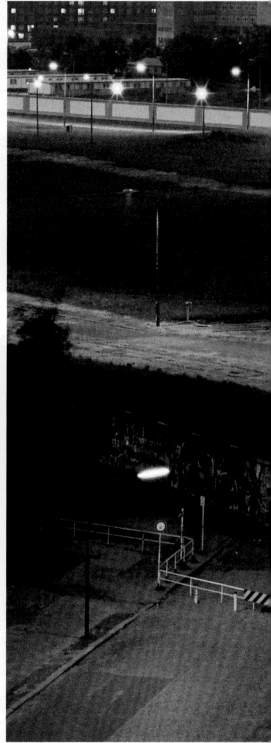

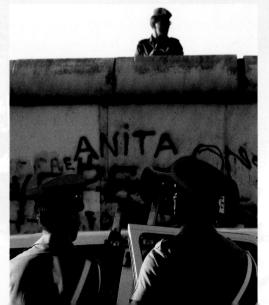

Far left:
Standoffs between East German soldiers and Allied troops were common practice during the Wall era.

Top left:
The giant mirror at the Berlin Wall Memorial on Bernauer Straße is a reminder of the tragic scenes which took place here in 1961.

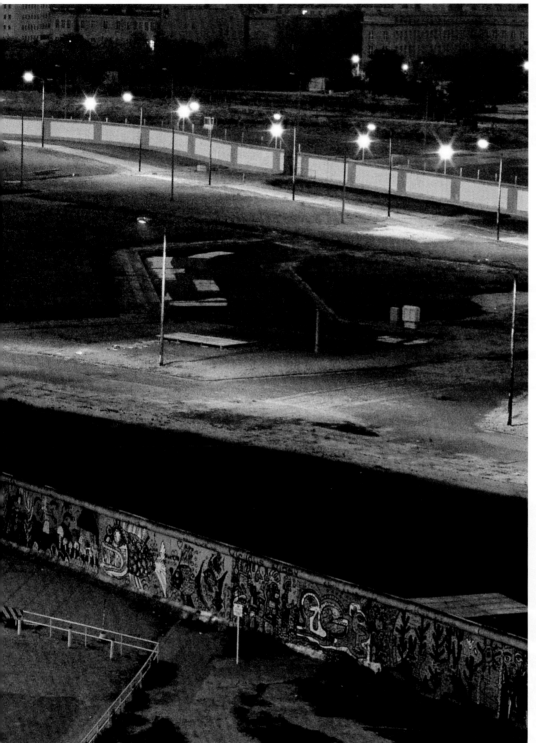

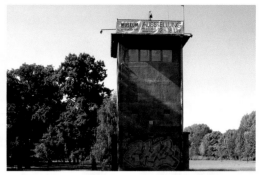

the Gestapo (»Topography of Terror«) and on the other the monumental Nazi architecture of Göring's old Imperial Air Ministry of the Third Reich which in the GDR period was the House of Ministries. After the fall of the Wall, Treuhand moved in and now the German minister of finance sits here dreaming up new ways of pilfering from the nation's pay packets.

SURREAL BERLIN MELANGE

His colleague, the German minister of trade and commerce, can also see the old Wall from his office. Now a promenade, this section leads along the Berlin-to-Spandau shipping canal and through the old Invalidenfriedhof, the cemetery of the war disabled where Prussian generals such as Scharenhorst and the fighter pilot Ernst Udet, alias the Devil's General after the Zuckmayer play, rest in peace. A large portion of the graveyard was levelled to make way for the Wall yet much has since been restored. A plaque commemorates the first life lost to the Wall. North of the cemetery the promenade meanders past a new building. The expanse of green in front of it sports one of the few remaining border watch towers, now a listed building. Together with the rather affected riverside ambience of the complex and a rather miserable sandpit for the children, the tower makes up a surreal Berlin melange which cannot fail to make an impression.

Above:
The view from Weinhaus Huth, the only original bit of Potsdamer Platz left standing. The fortifications of the Berlin Wall transformed what was and now once more is the pulsating heart of

the city into a deadly no-man's-land, the ruins of Hitler's chancellery under the mound at the centre of the photo a sorry reminder of what was.

Top right:
The old border control point Am Schlesischen Busch between Kreuzberg and Treptow has been left as a memorial.

Right:
Much of the Wall, the symbol of a divided Germany, was torn down after Reunification. There are only a few places left where you can make out its former route, such as here near Potsdamer Platz.

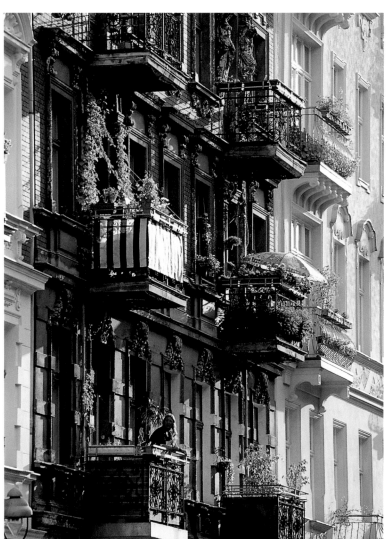

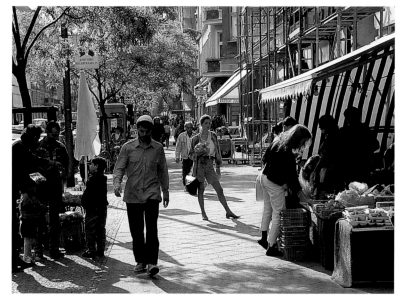

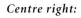

Centre right:
Bergmannstraße is a mixture of pubs, junk shops and ethnic grocers.

Right:
Riehmer's Hofgarten on Yorckstraße is a feat of bourgeois architecture.

Top left:
Sitting out on this profusely floral balcony in Kreuzberg is tantamount to going on holiday.

Below left:
In the year of its founding, 1980, the Tempodrom Cultural Forum still stood in the shadow of the Berlin Wall. Today the new building at the Anhalt Station is a top address for concerts, festivals and congresses.

Below:
Kreuzberg's artificial waterfall is crowned by the Schinkel monument commemorating the battles fought against Napoleon.

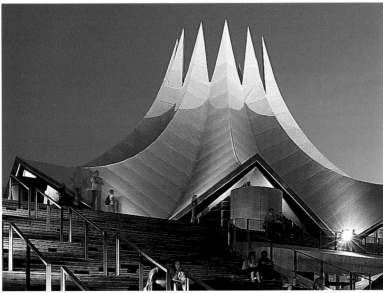

Page 110/111:
The River Spree is as wide as a lake here at Treptowers, an insurance stronghold. In the water stands the giant aluminium Molecule Men created by Jonathan Borofsky.

Page 112/113:
The International Congress Centre (ICC) beneath the Telecommunications Tower is known locally as the Starship Enterprise.

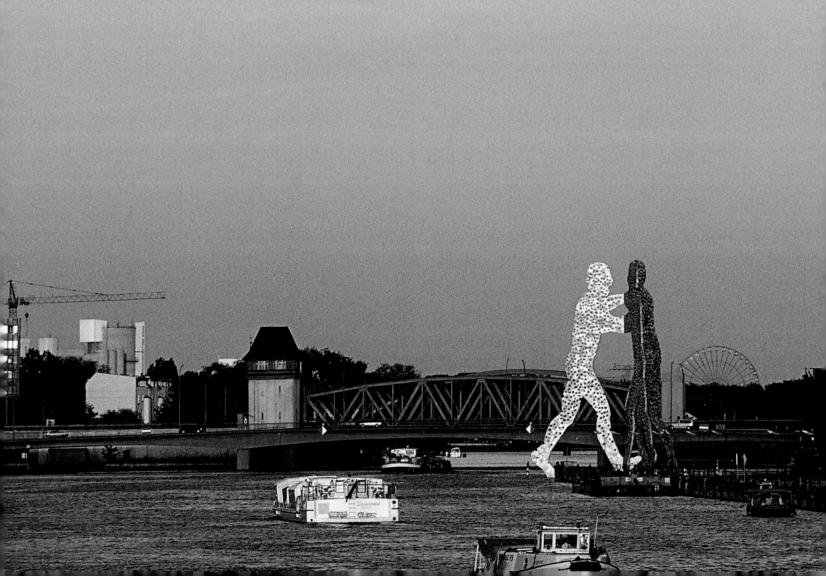

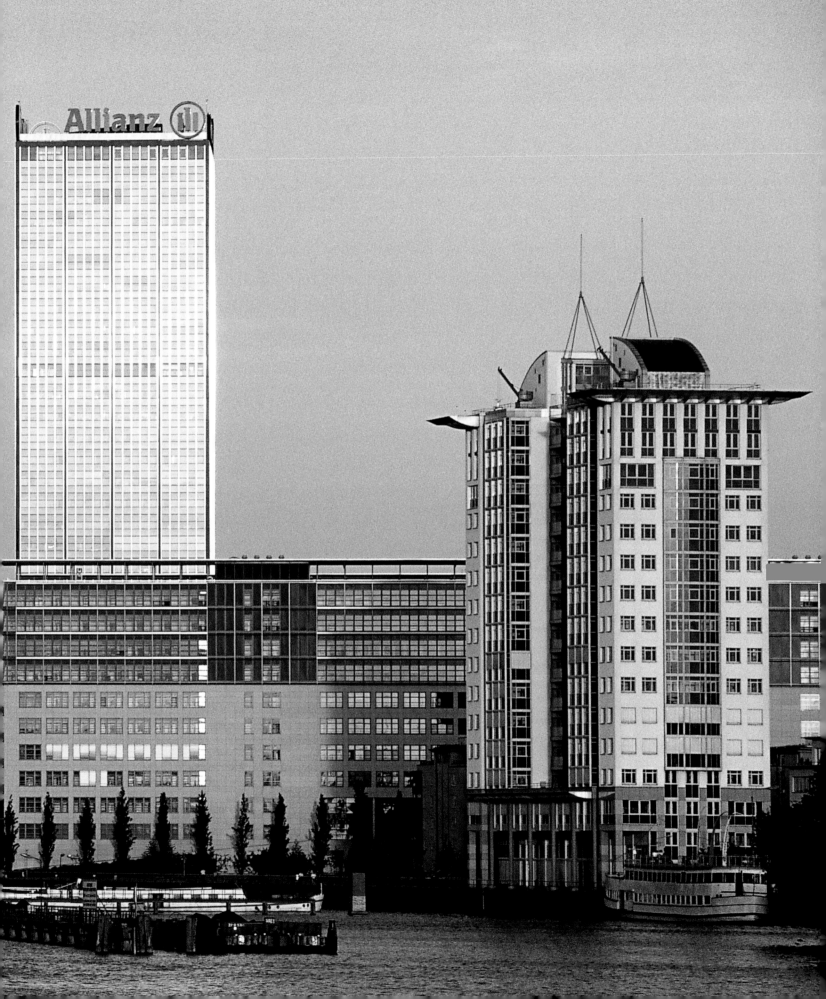

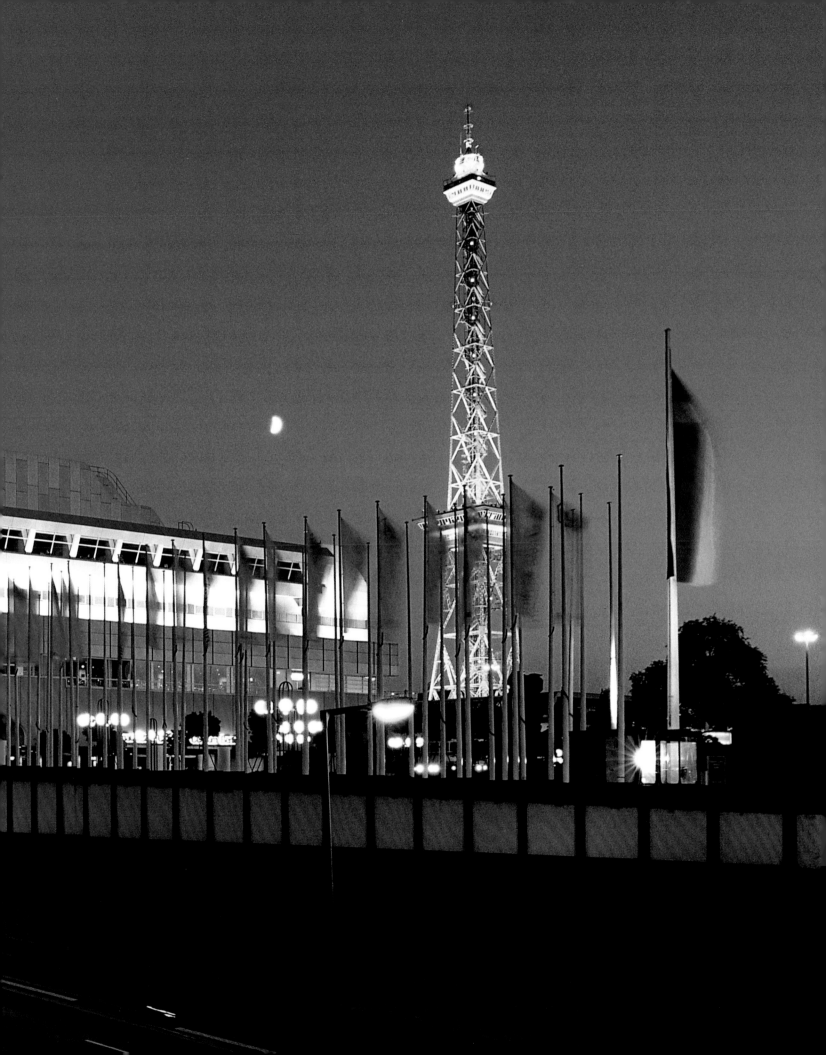

GETTING BACK TO NATURE

Part of Köpenick, Neu–Venedig (literally: »New Venice«) is a colony of parks and gardens on the water's edge. With its Müggelsee and expanses of forest the green belt to the south-east of the city is a popular place to come for the day, especially as it can be easily reached by train.

It is not always the German chancellor's motorcade which brings traffic in Berlin to an absolute standstill. It could be a tractor chugging off to the fields in Gatow during the rush hour. The occasional farm is just as much a part of city life as the fishermen on the River Havel or the foresters in Düppeler Forst out stalking the wild boar who dig up the front gardens out in the sticks. And that is precisely where you feel you are when, standing on top of the tower in Grunewald, you gaze out over treetops and the glittering Havel, totally oblivious of the 3.5 million city dwellers going about their business beneath you. With its 400,000 urban trees and wide expanses of forest and parks Berlin is more than just a city of green; its numerous stretches of water provide it with an excellent source of outdoor entertainment to boot. On summer weekends the huge Müggelsee resembles an Impressionist painting with the hundreds of sails dotted about the lake; in harsh winters Krumme Lanke and Großglienicker See become a paradise for skaters. In the mind of Kurt Tucholsky, »Ku'damm up front and the Baltic behind you« is the ideal topography for Berlin – and his sentiments seem to have been echoed. As in the Docklands of London, life on the water is being rediscovered in Berlin; take the peninsula of Stralau, for example. Affinities with nature have long been indulged by the upper classes in their villas in Grunewald, Wannsee and Dahlem. The latter district, for example, is a top favourite with members of parliament. Strolling through their local area and chewing over the pros and cons of abandoning atomic energy MPs may well wander past the building where nuclear fission was discovered in 1938. This goes to show that nature and cultural history are never far apart in Berlin. The perfect embodiment of this are the landscaped gardens of Peter Josef Lenné, the creative mind behind the Pfaueninsel and the palace parks at Niederschönhausen and Klein-Glienicke. The 19th-century designs of Lenné find their Far Eastern counterpart in the recently opened Garden of the »Regained Moon« in Marzahn, the largest Chinese garden in Europe.

Below:
Prussian paradise gardens surround the small white palace on the Pfaueninsel
Frederick William II had built for his mistress Wilhelmine Encke as a romantic ruin.

Left page:
Each summer tens of thousands of sun–loving individuals flock to the Wannsee to bake and bathe at the biggest inland lido in Europe.

Below:
When there's a good wind sailors have to share the Müggelsee with vast numbers of fellow enthusiasts.

Below:
The fish Wolfram Ludwig catches here south of Spandau end up on the menu at the local lake-side restaurant.

Above:
Großglienicker See is said to have the cleanest water in Berlin.

Above:
The Müggelsee is the largest lake in Berlin and a hot favourite with city dwellers seeking respite from the bustle of the town.

119

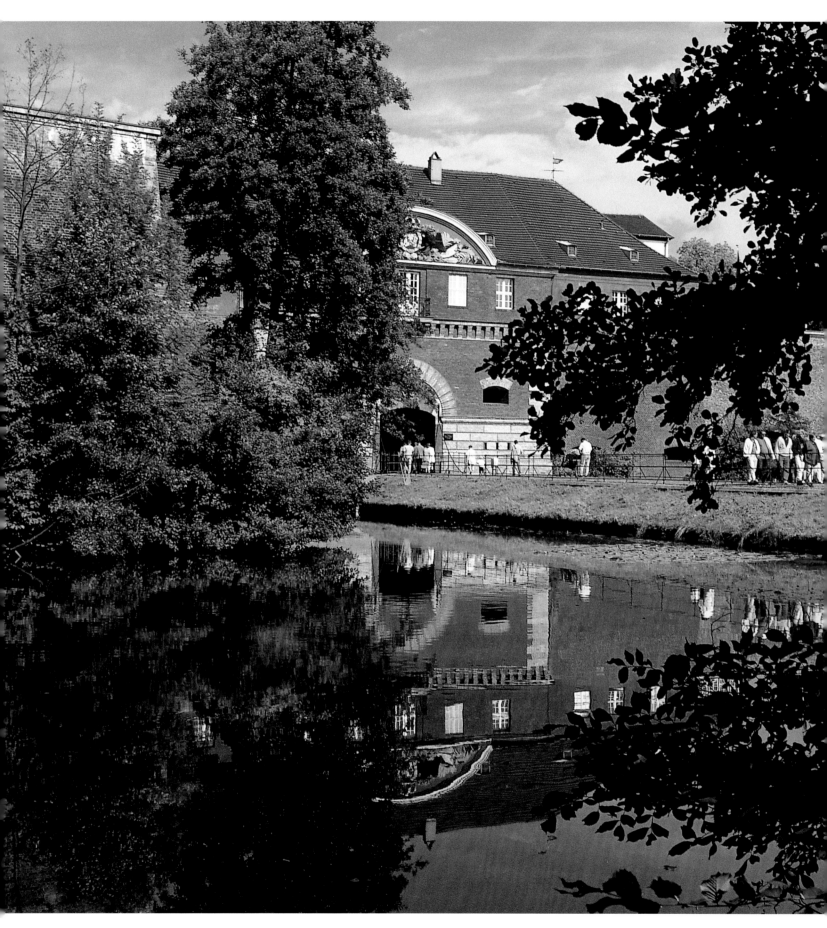

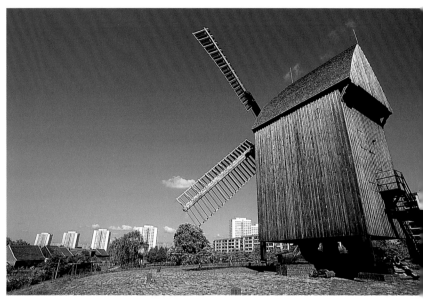

Left:
The fortress at Spandau is based on Italian military models. In the oldest part of the Citadel, the Juliusturm dating back to c. 1200, Germany's war reserves were hoarded after 1870/71.

Below:
Much of the prefab satellite town of Marzahn was built on farmland. The lovingly restored local windmill is a proud monument to Marzahn's agricultural past.

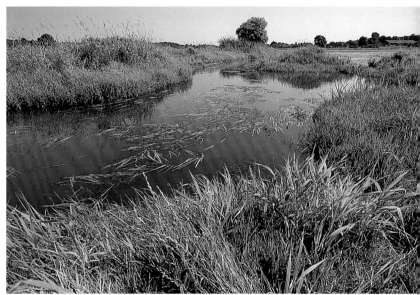

Above:
Get back to nature at the Tegeler Fließ conservation area in Reinickendorf, a stretch of land formed by glaciers.

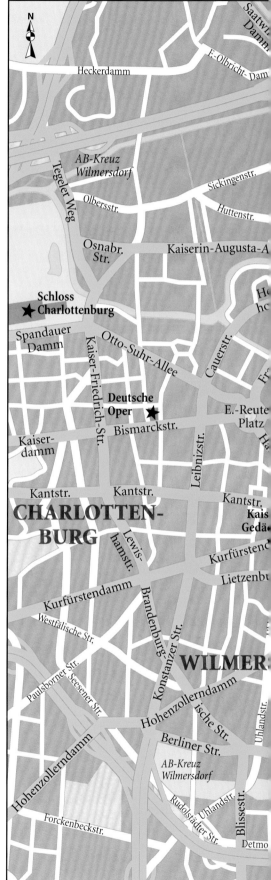

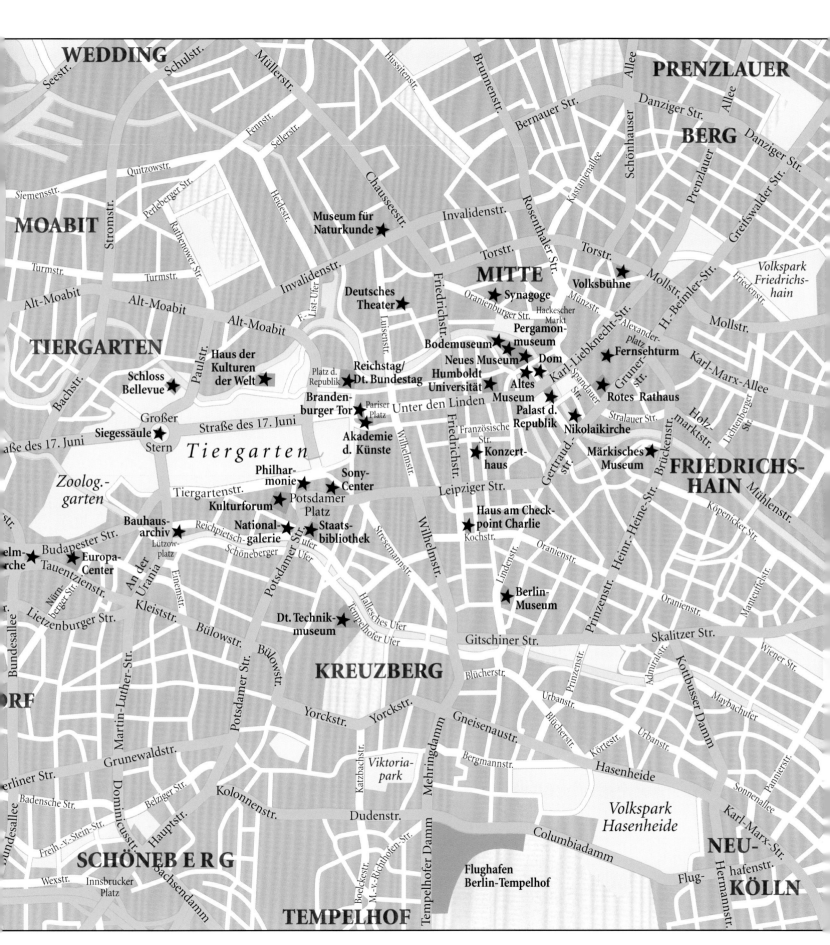

WEDDING

Schulstr.

Seestr.

Müllerstr.

Chausseestr.

Brunnenstr.

PRENZLAUER

Danziger Str.

Allee

Quitzowstr.

Fennstr.

Sellerstr.

Bernauer Str.

Schönhauser

BERG

Danziger Str.

Siemensstr.

Perleberger Str.

Rathenower Str.

Heidestr.

Invalidenstr.

Kastanienallee

Prenzlauer

Greifswalder Str.

MOABIT

Stromstr.

Turmstr.

Museum für
Naturkunde ★

Rosenthaler Str.

Torstr.

Torstr.

Mollstr.

Volkspark
Friedrichs-
hain

Alt-Moabit

Alt-Moabit

Invalidenstr.

MITTE

Volksbühne ★

Mollstr.

H.-Beimler-Str.

Friedenstr.

TIERGARTEN

Alt-Moabit

F.-List-Ufer

Luisenstr.

Deutsches
Theater ★

Oranienburger Str.

★ Synagoge

Hackescher
Markt

Münzstr.

Mollstr.

Haus der
Kultur en
der Welt ★

Friedrichstr.

Pergamon-
museum

Bodemuseum ★

Neues Museum

★ Dom

Alexander-
platz

★ Fernsehturm

Karl-Marx-Allee

Schloss
Bellevue ★

Bachstr.

Paulstr.

Platz d.
Republik

Reichstag/
Dt. Bundestag ★

Humboldt
Universität

Altes

Karl-Liebknecht-Str.

Spandauer Str.

Gruner-
str.

★ Rotes Rathaus

Lichtenberger Str.

Großer

Brandenburger Tor ★

Pariser
Platz

Unter den Linden

Museum
Palast d.
Republik

Stralauer Str.

Holz-
markt-str.

Stern

Straße des 17. Juni

★ Siegessäule

aße des 17. Juni

Tiergarten

Akademie
d. Künste ★

Wilhelmstr.

Friedrichstr.

Französische
Str.

Nikolaikirche ★

Gertraud-str.

Märkisches
Museum ★

Brückenstr.

FRIEDRICHS-
HAIN

Mühlenstr.

Zoolog.
garten

Philhar-
monie ★

Sony-
Center ★

★ Konzert-
haus

Köpenicker Str.

Tiergartenstr.

Leipziger Str.

Kulturforum ★

Potsdamer
Platz

Bauhaus-
archiv ★

Reichpietsch-
ufer

National-
galerie ★

Potsdamer Str.

Staats-
bibliothek ★

Stresemannstr.

Haus am Check-
point Charlie ★

Kochstr.

Heinr.-Heine-Str.

Prinzenstr.

Oranienstr.

Oranienstr.

Manteuffelstr.

elm-
rche ★

Budapester Str.

Europa-
Center ★

An der
Urania

Lützow-
platz

Schöneberger

Schöneberger Ufer

Einemstr.

Wilhelmstr.

Lindenstr.

Oranienstr.

Berlin-
Museum ★

Tauentzienstr.

Nürn-
berger Str.

Kleiststr.

Halleschfes Ufer

Tempelhofer Ufer

Gitschiner Str.

Skalitzer Str.

Wiener Str.

Lietzenburger Str.

Bülowstr.

Bülowstr.

Dt. Technik-
museum ★

Tempelhofer Ufer

Blücherstr.

Urbanstr.

Blücherstr.

Kottbusser Damm

Maybachufer

RF

Bundesallee

Martin-Luther-Str.

Dominicusstr.

Yorckstr.

Yorckstr.

KREUZBERG

Gneisenaustr.

Urbanstr.

Körtestr.

erliner Str.

Grunewaldstr.

Belziger Str.

Kolonnenstr.

Katzbachstr.

Viktoria-
park

Bergmannstr.

Hasenheide

Karl-Marx-Str.

Sonnenallee

Badensche Str.

Freih.-v.-Stein-Str.

Hauptstr.

Sachsendamm

Dudenstr.

Mehringdamm

Tempelhofer Damm

Columbiadamm

Volkspark
Hasenheide

NEU-

Wexstr.

Innsbrucker
Platz

SCHÖNEB E R G

Boelckestr.

M.-v.-Richthofen-Str.

Flughafen
Berlin-Tempelhof

Flug-

hafenstr.

Hermannstr.

KÖLLN

TEMPELHOF

At Juliette's Literatursalon on Gormannstraße connoisseurs of the book listen enthralled to a literary reading.

Credits

Design
hoyerdesign grafik gmbh, Freiburg

Map
Fischer Kartografie, Fürstenfeldbruck

Translation
Ruth Chitty, Schweppenhausen

Die Deutsche Bibliothek – CIP catalogue record
Journey through Berlin / Volker Oesterreich (author).
Jürgen Henkelmann (photographer) – Würzburg :
Verlagshaus Würzburg, 2002
ISBN 3-8003-1552-1

Printed in Germany
Repro: Artilitho, Trento, Italien
Printed by Konkordia Druck GmbH, Bühl
Bound by Josef Spinner Großbuchbinderei GmbH,
Ottersweier
© 2002 Verlagshaus Würzburg GmbH & Co. KG
© Photos: Jürgen Henkelmann

ISBN 3-8003-1552-1

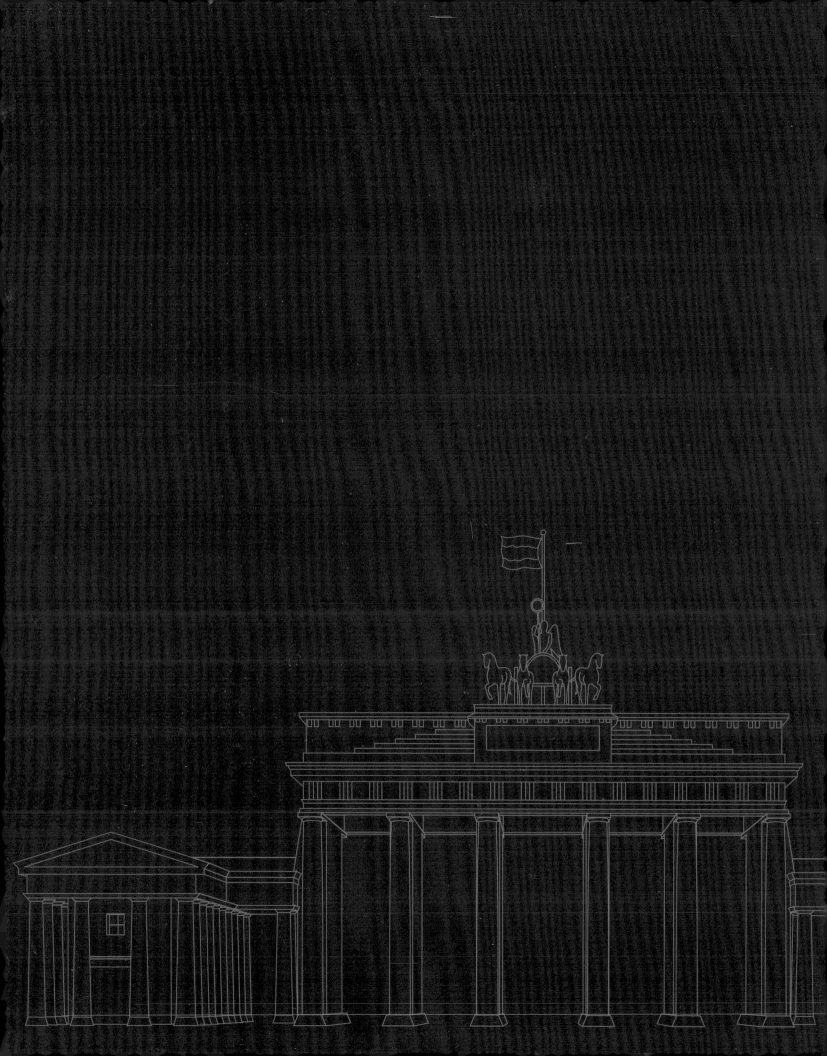